The Campus History Series

THOMAS NELSON
COMMUNITY COLLEGE

The Campus History Series

THOMAS NELSON
COMMUNITY COLLEGE

RICHARD A. HODGES
FOREWORD BY PRES. JOHN T. DEVER

ARCADIA
PUBLISHING

Published by Arcadia Publishing
Charleston, South Carolina

Printed in the United States of America

Library of Congress Control Number: 2018932649

For all general information, please contact Arcadia Publishing:
Telephone 843-853-2070
Fax 843-853-0044
E-mail sales@arcadiapublishing.com
For customer service and orders:
Toll-Free 1-888-313-2665

Visit us on the Internet at www.arcadiapublishing.com

CONTENTS

FOREWORD

The 50th anniversary of Thomas Nelson Community College provides a welcomed occasion to look back over the remarkable history of this institution that has played such a vital role in the life of the Virginia Peninsula. Equally, it is an opportunity for those of us at the college and in the community to rededicate ourselves to the college's essential mission of making the benefits of high quality and affordable collegiate and career education readily accessible to all members of our society.

Through text and photographs, this book chronicles the experiences of the countless students whose lives have been changed for the better because of what they gained from attending Thomas Nelson. And it recounts the efforts of the many faculty, staff, administrators, board members, and community leaders who have made all this possible. We owe so much to those who had the vision for the college in the 1960s and to all those over the years who have worked with such dedication to make that vision a reality.

Thomas Nelson has always prided itself on being a resource for those who have looked to its educational programs and services as a way of realizing their aspirations for personal and professional success. Likewise, the college has worked diligently to be responsive to the needs of employers for a well-educated and highly skilled workforce. As a result of Thomas Nelson's presence for the past half-century, our community has enjoyed much greater economic prosperity and social well-being.

Thomas Nelson distinguishes itself in the way we have partnered with businesses and communities whose support is essential for our accomplishments. These include the four cities (Hampton, Newport News, Poquoson, and Williamsburg) and the two counties (James City and York) that comprise our service area and that appoint the representatives who serve on the college board. They also include other community members who have generously dedicated themselves to supporting special institutional initiatives through the private resources provided by the Thomas Nelson Educational Foundation. The college works very closely with the peninsula school systems to see that all young people have a pathway to post-secondary success, and then with university colleagues and regional employers to see that our graduates move on successfully to further education and productive careers. We take particular pride in working with the military to see that active-duty personnel, veterans, and their family members receive the benefits of higher education.

Fortunate to be located in a region so closely tied to the founding of our country, the college takes continuing inspiration from its namesake, Thomas Nelson Jr. of Yorktown, who contributed much to the American quest for independence and democratic values.

—John T. Dever
President

ACKNOWLEDGMENTS

The history of Thomas Nelson Community College is a story about people. The people who came together to make Thomas Nelson a success are indirectly responsible for the creation of this book, for it is their story that is told. The telling of this story and the creation of this book happened thanks to the work of many dedicated people. Without their steadfast dedication, this project would not have been possible. On behalf of Thomas Nelson Community College, I would like to acknowledge and thank the following: Dr. John Dever, Chancellor Glenn Dubois, Chancellor Emeritus Dana B. Hamel, Dr. Lonnie Schaffer, Charles Nurnberger, Lisle Wilke, Cynthia Callaway, the State Board for Community Colleges, the Thomas Nelson Community College Archives, the Thomas Nelson Community College Libraries, the *Daily Press*, the *Richmond Times-Dispatch*, the Library of Virginia, Michael Wesser, the Organizing and Planning Committee for the 50th Anniversary of Thomas Nelson Community College, the Thomas Nelson Educational Foundation Board of Directors, the Thomas Nelson Local College Board, and all the current and past employees and students who have passed through the doors of Thomas Nelson over the past half-century. The photographs selected for this history, and their alignment with the proper historical periods, are the work of Richard A. Hodges along with Susan Lawlor and Laura Hannon of the Thomas Nelson Community College Archives; unless otherwise noted, all images in this book appear courtesy of these archives. The captions for this book were written and edited by Richard A. Hodges, Susan Lawlor, and Laura Hannon.

INTRODUCTION

In 1966, Dr. Dana B. Hamel, director of the newly formed Virginia Department of Community Colleges, drove from Richmond to Hampton to view a possible site for the department's first college in the Tidewater–Hampton Roads region. That site would become the future home of Thomas Nelson Community College. In recalling the trip, Hamel said he got lost trying to find the property, but when he finally did, what he found was a beautiful tract of land covered in dense forest and swamps. Even so, Hamel liked the site's location. Meeting Hamel that day was Dr. Gordon Sweet, president of the Southern Association of College and Schools (SACS). Hamel and Sweet examined the property and agreed it would be perfect for the placement of a new college. After looking over the plans and examining the property, Sweet reportedly told Hamel, "Dana . . . you will get your million-dollar letter." The letter Sweet was referring to awarded the new college conditional accreditation from SACS. Accreditation was and remains vital to the success of any college, as it allows the institution to be eligible for federal funding.

On March 16, 1967, the architectural firm Forrest Cole and Associates in Newport News hosted the first meeting of the new college's advisory board. The board met in the firm's conference room. One of the first orders of business was to establish a name for the soon-to-be college. The first name to appear in the newspapers had been Peninsula Community College, and later George Wythe Community College, named for the Hampton native. It was not until the third meeting of the board that the name Thomas Nelson was decided upon. A Yorktown native, Thomas Nelson Jr. had served as governor of Virginia and as a brigadier general during the American Revolution. Along with Thomas Jefferson and George Wythe, Thomas Nelson Jr. was a founding father and signer of the Declaration of Independence.

This book tells the story of the first 50 years of Thomas Nelson Community College. The story is told through the words and images of people who walked through its doors in search of a better life for themselves, their families, and their communities.

The college's cornerstone was placed in December 1967, and classes began in September 1968. As in its beginning, Thomas Nelson continues to offer workforce training and college transfer opportunities to students from Hampton, Poquoson, Newport News, Williamsburg, James City County, and York County. Today, students can choose from a variety of educational institutions on the Virginia Peninsula, but it is the inclusive, nurturing atmosphere of Thomas Nelson that continues to attract students to its campuses in Hampton and Williamsburg.

The importance of Thomas Nelson can best be understood by placing its founding in the context of the early to mid-1960s. At that time, Virginia was emerging from a socially turbulent time known as "massive resistance," Virginia's political response to the 1954 US Supreme Court rulings in *Brown v. Board of Education*. The unintended consequences of massive resistance created a contested environment that existed from 1956 through much of

the 1960s, setting Virginia on a path that proved destructive to its public education system, business community, and national reputation. The closing of public schools along with a stagnant business environment prompted government, in partnership with the business community, to eventually create one of the most extraordinary higher educational institutions in the country: The Virginia Community College System (VCCS). The establishment of this 23-college system in 1964, first as a system of technical colleges, set Virginia on a path to economic and social prosperity by quickly providing something desperately needed: education and job training throughout the commonwealth. In 1966, the schools officially changed from technical to comprehensive community colleges, offering a college transfer curriculum alongside existing technical programs.

Thomas Nelson Community College has experienced many changes throughout its 50 years. What began with three buildings and 1,200 students has grown to two campuses totaling 10 buildings and two workforce centers serving over 13,000 students annually in transfer education and over 5,000 in workforce training. Thomas Nelson has grown to be one of the largest of the 23 Virginia community colleges. Along with on-campus programs, Thomas Nelson has a vibrant online education program and an active dual-enrollment program whereby high school students receive credit for college courses.

Its economic impact on the community is significant. Thomas Nelson Community College contributes much to the prosperity of the Virginia Peninsula. A 2014 study showed the annual economic impact on the region to be $330 million, with a high rate of return on investment for students, taxpayers, and society as a whole. The major impact comes from alumni, three-quarters of whom remain in the region and contribute to the economy through the value they bring to employers.

We at Thomas Nelson are proud of our past and excited as we look ahead to a future of endless possibilities.

One

BEGINNINGS

The college's cornerstone-laying ceremony took place on December 15, 1967. The day's events began with a luncheon at the Holiday Inn for some 250 guests from area political, educational, military, and business circles, plus members of the State Board for Community Colleges and directors from the Virginia Community College System's Richmond office. Speakers included Eugene B. Sydnor, former state senator and chairman of the state community college board; Dr. Dana B. Hamel, director of the Virginia Department for Community Colleges; T. Melvin Butler, chairman of the Thomas Nelson Local College Board; Dr. Thomas V. Jenkins Jr., Thomas Nelson Community College president; and D. Boyd Thomas of Newport News, member of the state board. Pictured here with the cornerstone are, from left to right, Hamel, Sydnor, and Butler. (Courtesy of the Daily Press Media Group.)

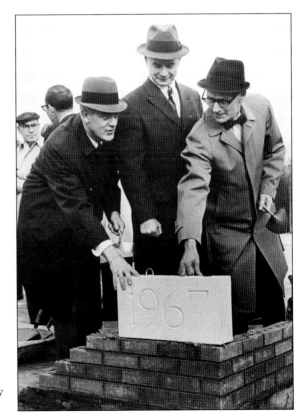

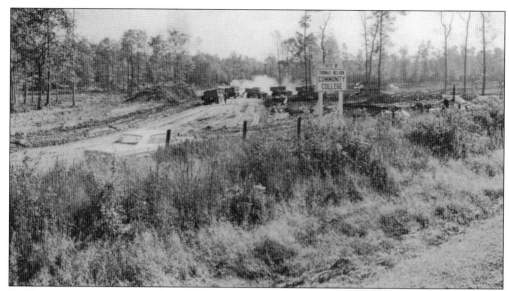

Deliberation over the best location for the peninsula's new community college began in 1966 with the formation of a local advisory board. The board sought a centrally located plot of at least 100 acres near the center of the peninsula population and surrounded by about 30 miles of commuting area. Land surveys and negotiations with local governments and property owners ensued, and several months later, a site was chosen in the northwest area of Hampton. This photograph shows the site in the early stages of preparation in 1967. (Courtesy of the Daily Press Media Group.)

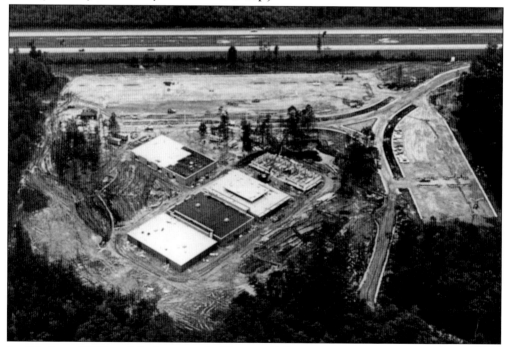

In this June 1968 aerial photograph, Thomas Nelson Community College builders are racing to complete the $1.4-million facility on Big Bethel Road in time for fall classes. (Courtesy of the Daily Press Media Group.)

The architectural firm of Marcellus Wright and Associates in Richmond was chosen to create a prototype that would be used as a model for construction of the new technical colleges. In this photograph taken on April 6, 1966, Gov. Mills Godwin (left) looks over a model of a prototype technical college, with state senator Lloyd C. Bird (center) of Chesterfield and Delegate D. French Slaughter Jr. of Culpepper, chief patrons of the bill establishing the technical college system. The name was later changed to the Virginia Community College System. While several colleges began by moving into existing buildings, Thomas Nelson was one of the first to build from the ground up. (Courtesy of the *Richmond Times-Dispatch*.)

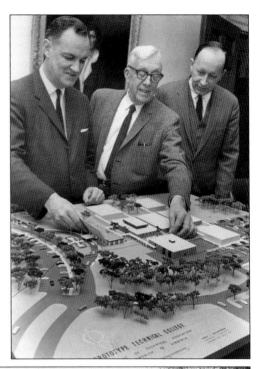

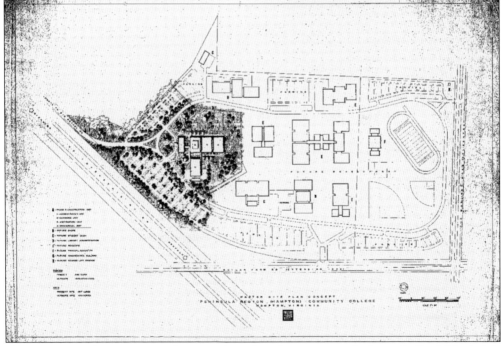

This concept drawing was the template for the campus design of all of Virginia's community colleges. Designed by Marcellus Wright and Associates, the template was intended to serve as a starting point for communities where a new college was to be constructed. The local college boards would employ local architectural firms to adapt the design to the needs of the surrounding community.

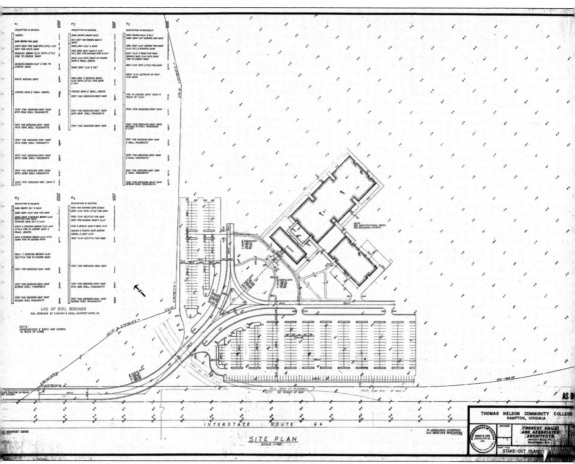

The similarities between the Marcellus Wright prototype campus and this 1967 site plan of Thomas Nelson are notable. The buildings outlined in the plan are Harrison, Moore, and Diggs Halls. The site plan, designed by Newport News architectural firm Forrest Coile and Associates, does not include the athletic fields suggested in the concept plan drafted by Marcellus Wright and Associates.

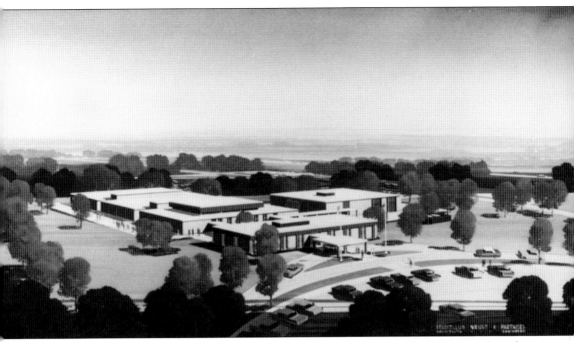

On March 18, 1967, the *Daily Press* reported: "Architects today unveiled building plans for the Peninsula's Community College—a $1,876,000 project which includes three separate buildings connected with covered walkways covering 58,000 square feet. The plans are a prototype for the 22 colleges to be built across the state and were drawn originally by Marcellus Wright of Richmond. Forrest Coile Associates are the local architects who are handling modifications of site and building to meet Peninsula needs." Pictured is an artist's rendering of the planned college showing what would become Harrison, Diggs, and Moore Halls.

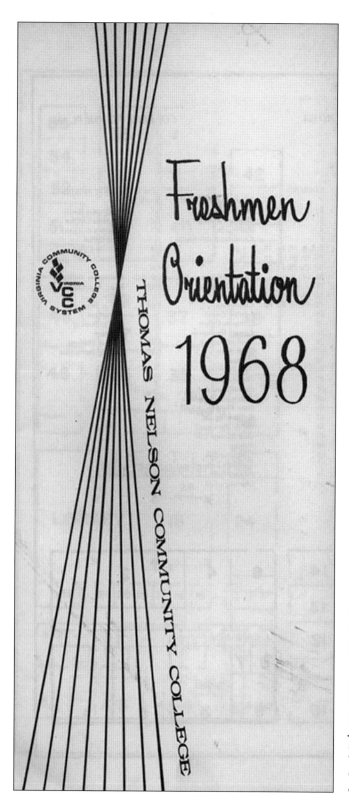

Freshmen Orientation 1968

THOMAS NELSON COMMUNITY COLLEGE

Pictured is the cover of the first freshman orientation brochure from 1968. The first class of Thomas Nelson students attended an 11-day orientation between September 25 and October 14, 1968. President Jenkins said that academic success for every student at Thomas Nelson Community College was the goal of the orientation.

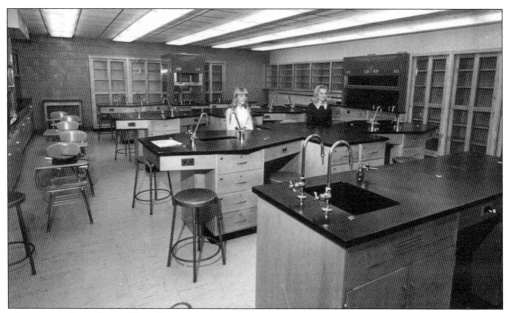

Thomas Nelson has offered associate of science and associate of applied science degrees since the beginning. The student bulletin of 1968–1969 noted that "with the tremendous emphasis on scientific discoveries and technological developments in today's society, there is a great demand for scientists and scientifically-oriented persons in business, government, industry, and the professions." In 1968, the science laboratory was located in Diggs Hall. Here, students patiently wait for class to begin. (Courtesy of the Daily Press Media Group.)

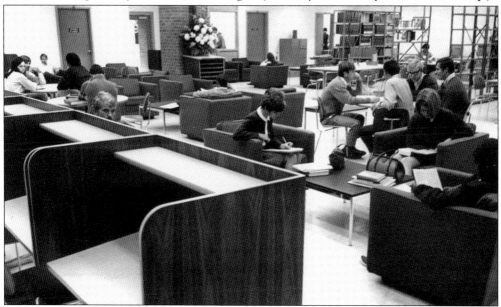

One of the priorities of the administration of President Jenkins was the creation of a library for Thomas Nelson students. According to the 1969 accreditation report of the Southern Association of Colleges and Schools, nine percent of the overall 1968 college budget was allocated in support of the library. The library is pictured here in 1968, still in development. (Courtesy of the Daily Press Media Group.)

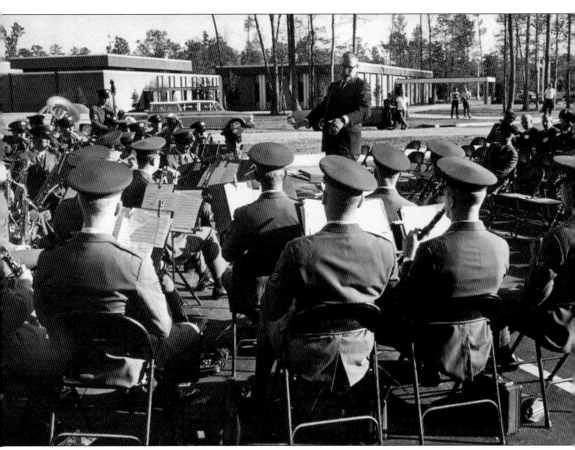

J. Clifton Williams, longtime friend of President Jenkins, was one of America's foremost composers of band music; their friendship stemmed from when they were both faculty members at the University of Texas. Williams readily accepted Jenkins's invitation to come to the college's dedication and premier his new composition, "The Patriots." Williams, also the composer of the US Air Force Academy alma mater, had already decided to dedicate "The Patriots" to NASA, as it currently had no official anthem. Jenkins said that one of the college's goals was to serve the community in ways beyond the traditional curriculum, and that bringing this famous composer and NASA together was an example of how the college could serve in the cultural arts. The Tactical Air Command Band from NASA-Langley premiered "The Patriots" at the college's dedication ceremony on October 4, 1968, under the direction of Williams himself. (Courtesy of the Daily Press Media Group.)

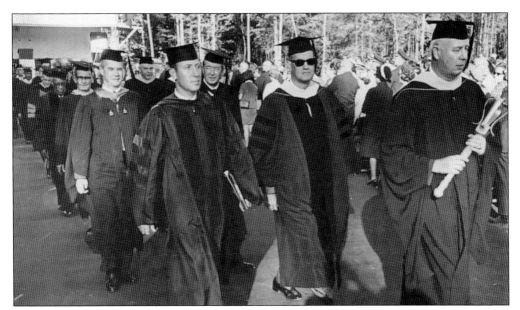

President Jenkins and Governor Godwin (wearing sunglasses) follow college marshal and mathematics faculty member Joseph P. Costello at the dedication of Thomas Nelson Community College in 1968. The Hon. Eugene Sydnor, chair of the state board, follows Jenkins in the procession. (Courtesy of the Daily Press Media Group.)

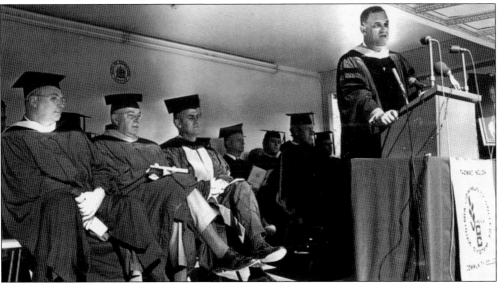

"Before the advent of community colleges, many thought it was utter folly to even dream of creating an institution of higher learning from scratch in a few brief years. And yet it was less than eleven months ago that the cornerstone was laid for Thomas Nelson Community College, and today it is preparing to open its doors for almost 1,200 students," noted Governor Godwin at the dedication of the college on October 4, 1968. "Those of us who so strongly advocate a community college program placed our bets on the people of Virginia, and it has warmed our hearts as few things could to use their overwhelming response." At the podium is Governor Godwin. Seated behind him is Dr. Dana B. Hamel, chancellor of the Virginia Community College System. (Courtesy of the Daily Press Media Group.)

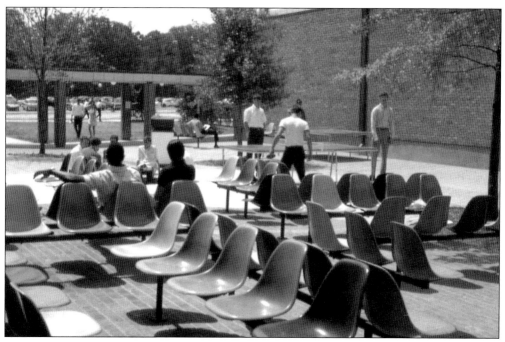

Shortly after its opening, the college recognized a need for a space for students to relax between classes. To accommodate this need, an outdoor lounge area was created between Moore and Diggs Halls. In the early 1970s, the space was covered over when the two buildings were connected. The local college board minutes of April 1971 discuss the new space: "The plans provide for student lounge area with space for vending machines and short order food, plus two offices, probably to be used by student activities."

Students are pictured relaxing outdoors between classes in early 1969.

In celebration of the 50th anniversary of the founding of Thomas Nelson Community College, Dr. Dana B. Hamel sent a letter to the president of the college, Dr. John T. Dever. Hamel was the founder of the Virginia Technical College System in 1964. In 1966, the system was converted to the Virginia Community College System (VCCS). Hamel served as the VCCS's founding chancellor until his retirement in 1979. The letter congratulated the college on achieving this milestone and relates the story of Hamel's first visit to the site in Hampton where the main campus stands today. Hamel apparently got lost locating the site.

Junes 1, 2017

Dr. John T. Dever, President
Thomas Nelson Community College
Post Office Box 9407
Hampton, Virginia 23670

Dear Dr. Dever:

As I think back on the founding of Thomas Nelson Community College and the VCCS, it is hard to believe that a half century has passed. What an accomplishment ! Memories take me back to those challenging and wonderful years. Problems, yes - but, they were opportunities in work clothes.

During the early 60's there was a movement in the South to attract industry to provide jobs and to improve the economy. Several Southern states began this journey ahead of Virginia and by 1964 it became a challenge for the Commonwealth ! We, too, needed jobs and increased access to higher education.

To meet the overwhelming demand Governor Harrison and Governor Godwin, working with the State Legislature, created the State Board for Technical Education which later became the State Board for Community Colleges. By June of 1966 a master plan had been developed and twenty three regions in the Commonwealth had been identified and eligible for technical / community colleges.

A review of the State Board minutes from that time, show that the members unanimously concluded Hampton Roads would be given priority over nine other locations in the state.

Shortly after this action, I visited Hampton Roads to view the land which is the current Thomas Nelson campus. It was an excellent location meeting all of the requirements set by the State Board. Standing with me in an open field of trees and bushes was the head of the College Division of the Southern Association of Colleges & Schools (SACS) whom I had invited to review the site to assure it met SACS standards. We discussed the site and he turned to me and said : "Dana, you'll will get your million dollar letter!" which meant we would be eligible to apply for federal grants. Thomas Nelson was accredited on it's first day of classes and eligible for federal funds.

Thomas Nelson Community College is the Peninsula's Community College. Over the past fifty years the Local Boards, working with the State Board, and the Chancellor and his staff; coupled with the Presidents and the faculty and staff of Thomas Nelson Community College have made it possible for thousands upon thousands of students and Peninsula's citizens to stand on their shoulders and look over the horizon.

I salute you Dr. Dever, as President of Thomas Nelson Community College, the Peninsula's Community College and the fourth largest institution in the VCCS, for your achievements, your continuing vision, your immeasurable contributions, coupled with your outstanding leadership, for continuing to make it a : "A GREAT DAY TO BE ALIVE IN THE COMMONWEALTH"

Dana

Dana B. Hamel
Founding Chancellor
Chancellor Emeritus

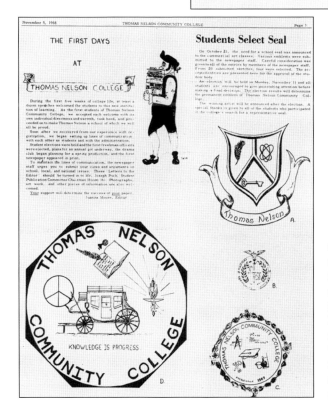

Contests were held among the student body for a name and image of a school mascot, a college seal, and a name for the student newspaper. In the days before computer graphics, all images in the college newspaper were hand-drawn. This page from the first edition of the student paper shows several entries for the college seal.

The winning college seal design was selected from eight different entries by student ballot. The motto reads, "*Succesus Per Educationem*" (Success through Education). The winning design was drawn by commercial art student John Moore and submitted by Robert Emerson. The original motto submission was "*Seccessus Tarati Educates*," which literally translates to "Victory Celebrate Education." The seal is still in use today.

"TNCC students are now officially the Swamp Stompers," noted *The Nelsonite* student newspaper on December 11, 1968. "The name was chosen in an election which also decided the school seal." This version of the Swamp Stomper was drawn by student Tucker Spurgeon. The Swamp Stomper overwhelmingly won over the other choices, which included Minutemen, Cougars, Tankards, Patriots, Trojans, and Governors.

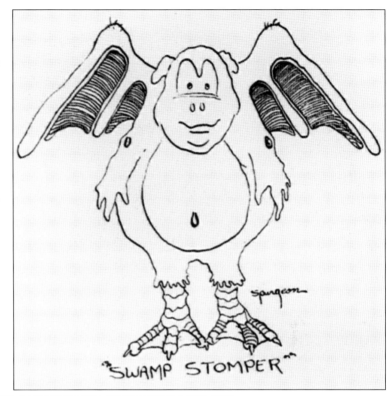

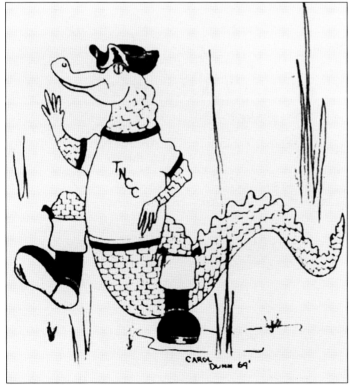

Very soon after the first sketch of the Swamp Stomper won the mascot competition, a revised interpretation was drawn by commercial art student Carol Dunn. This rendition of the Swamp Stomper appeared in a May 1969 edition of *The Nelsonite*.

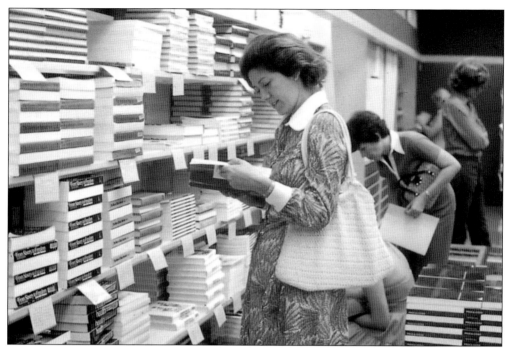

TNCC has always served the entire population of the Virginia Peninsula, including recent high school graduates, workers in need of skill development, and re-entry students seeking a mid-life career change. Here, a re-entry student in 1977 explores books and perhaps contemplates future directions in the college bookstore. To ensure the success of women seeking to transition into the workforce from the home, Thomas Nelson even created a displaced homemaker task force in 1980.

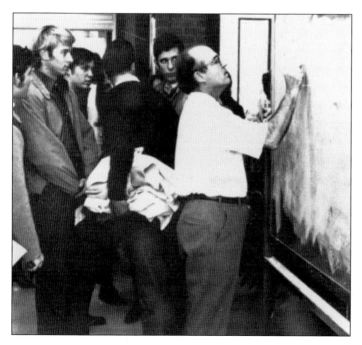

The *Daily Press* of September 17, 1968, reported: "An atmosphere of expectancy surrounded Thomas Nelson Community College in Hampton Monday as 43 faculty members began getting acquainted. The instructors of the college which is in its opening year will be on hand to greet the expected 900 freshmen who will descend on the campus September 25, which is orientation day. Classes are scheduled to start September 30."

Dr. Thomas V. Jenkins Jr. served as the first president of Thomas Nelson Community College, from 1967 to 1971. Jenkins was chosen by the Thomas Nelson local board and the state board after a competitive search. Dr. Dana B. Hamel, founding chancellor of the Virginia Community College System, briefly served as Thomas Nelson's interim president prior to the hiring of Jenkins. This portrait of Jenkins hangs in the Moore Hall gallery outside of the Espada Conference Center. (Photograph by Michael Wessel.)

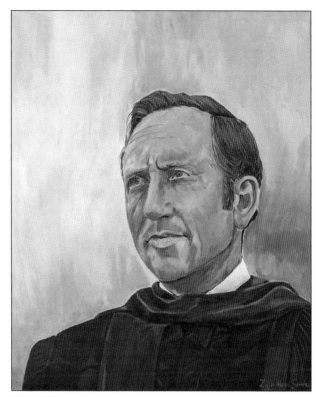

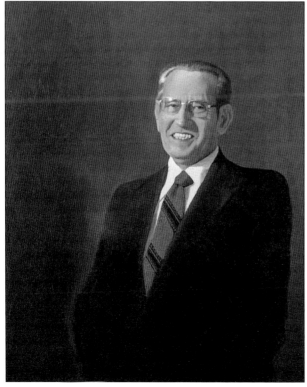

Dr. Gerald O. Cannon served as Thomas Nelson's second president. Cannon was dean of instruction from 1968 to 1971 and president from 1971 to 1979. The campus expanded during his tenure with the construction of Griffin and Wythe Halls. This portrait hangs in the Moore Hall gallery outside of the Espada Conference Center. (Photograph by Michael Wessel.)

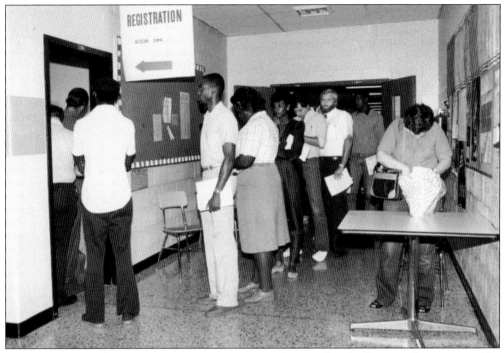

Students practiced patience as registration got underway for the first academic term. *The Nelsonite* described the scene in the November 5, 1968, edition: "People edged along the walls and squeezed their way through jostling elbows only to change direction in mid-stride. Class should be a snap after registration day."

"AND WHAT'S REALLY BAD IS HAVING TO·RENT A U-HAUL JUST ·TO GET MY BOOKS. TO AND. FROM SCHOOL EVERYDAY."

Five weeks into academic year 1968–1969, the November 5, 1968, edition of *The Nelsonite* asked students their opinion of "Tommy Tech," as some called the school. Student responses included: "A place of opportunity for those who don't have it;" "Outside of two to one ratio of boys to girls, Tommy Tech is fine;" "It's a good place to be, it's given me a second chance;" "The people are friendly;" and "It's nice; I wouldn't want to go anyplace else."

The college yearbook, *Impact*, described the library in these terms: "The 135 seat facility was well staffed and well equipped. Intellectual growth was promoted by the limited, but widely selected books and periodicals. Xerox machines, recorders, and micro-film were also available to all students. For the serious minded, study booths allowed uninterrupted concentration, while the average student relaxed in an easy chair and enjoyed the paintings by TNCC students, the atmosphere, and the constant flow."

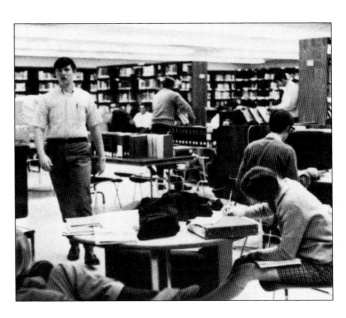

Pictured here is the staff of *The Nelsonite* relaxing between publications. The student newspaper was published from 1968 to 2007, although not every year.

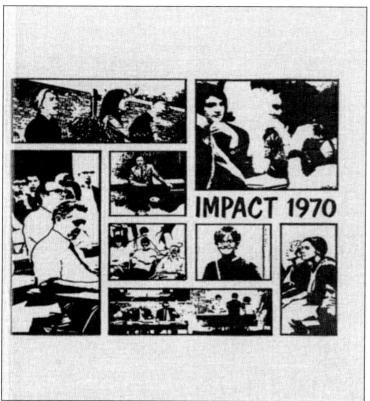

In its 50-year history, the college has only produced one yearbook. *Impact* was produced in 1970 and contained photographs and comments documenting the college's first two years of existence.

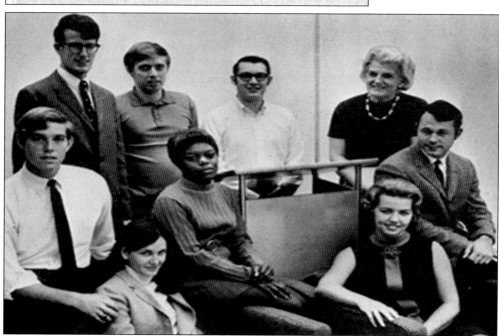

As identified in *Impact*, peer counseling was a new concept that was embraced by Thomas Nelson. Pictured here are students who participated in the program along with their faculty sponsor.

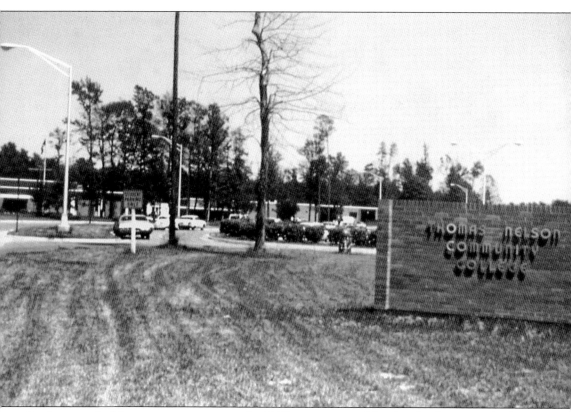

Students and visitors entering campus in 1968 were greeted by this brick sign with the name of the new college. Soon after the college opened, the college board decided to take advantage of the school's proximity to the highway and commissioned a replacement sign that could be seen from the adjacent Interstate 64.

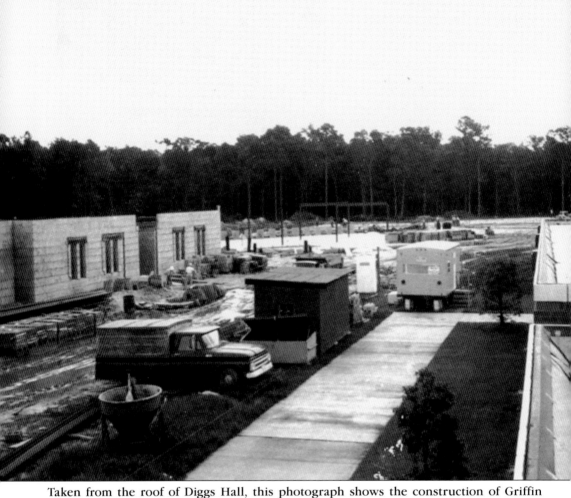

Taken from the roof of Diggs Hall, this photograph shows the construction of Griffin and Wythe Halls. Ground breaking took place on November 16, 1972. Some cinder block walls of Griffin are in place, with girders visible for additional sections of the buildings. The buildings were dedicated in a ceremony on November 10, 1974, at which Governor Godwin delivered the address and Dr. Dana Hamel, founding chancellor of the VCCS, cut the ribbon.

Pictured here is the ground breaking for Phase II at Thomas Nelson Community College in 1972. From left to right are Col. A.F. Penzold, chair of the building committee; Gerald O. Cannon, TNCC president; Dr. Daniel C. Lewis, chair of the state board; and Melvin Butler, chair of the Thomas Nelson local board. (Courtesy of the Daily Press Media Group.)

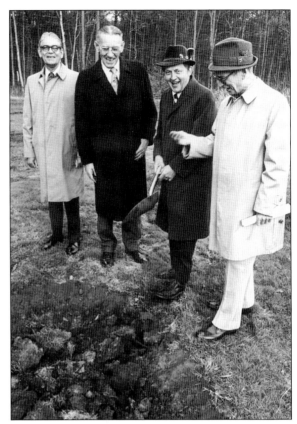

This 1972 photograph shows the entrance to TNCC. The building is the administration building, Harrison Hall. Missing is the college's now iconic Circle of Flags, constructed in 1976 to commemorate the nation's bicentennial.

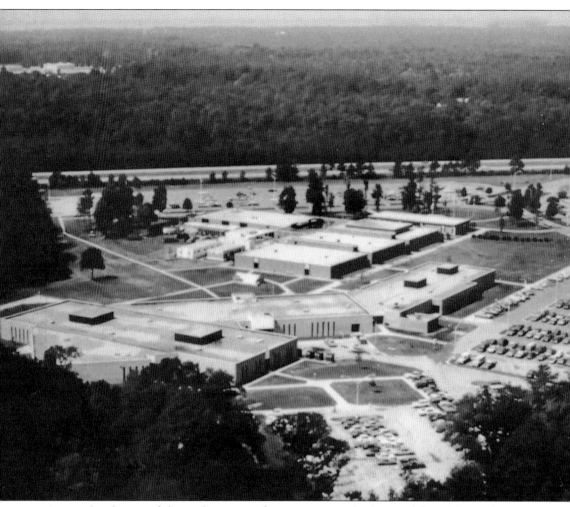

An overhead view of the early campus from 1975 reveals the need for additional parking lots. Campus newspapers from this time reported that people parked in the grass, along every inch of the roads leading up to the college, in front of fire hydrants, in emergency lanes, blocking access roads, and in every other available spot. Students were encouraged to walk or carpool.

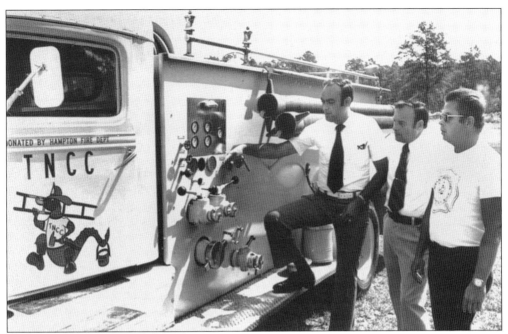

Pictured from left to right in 1973 are Rupert Terrier, Capt. Ernest Hale, and Frank Kearney with the college's fire truck donated by the Hampton Fire Department. The fire truck became a vital classroom tool for fire science students at TNCC. (Courtesy of the Daily Press Media Group.)

Thomas Nelson Community College students used new videotaping equipment to film the 1974 appearance by Governor Godwin at the dedication of Wythe and Griffin Halls. (Courtesy of the Daily Press Media Group.)

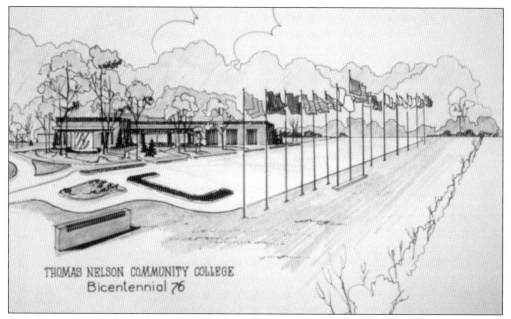

THOMAS NELSON COMMUNITY COLLEGE
Bicentennial 76

To commemorate the nation's 200th anniversary in 1976, TNCC chose to recognize its namesake's Patriot heritage. The original plan called for the construction of an avenue of flags, as depicted here. Due to a possible expansion of Interstate 64, the avenue concept was abandoned in favor of the circle.

THOMAS NELSON COMMUNITY COLLEGE
HAMPTON, VIRGINIA

The Circle of Flags still welcomes students and visitors to the campus. It stands at the entrance to the college's administration building, Harrison Hall. This drawing shows the original design chosen over the Avenue of Flags concept.

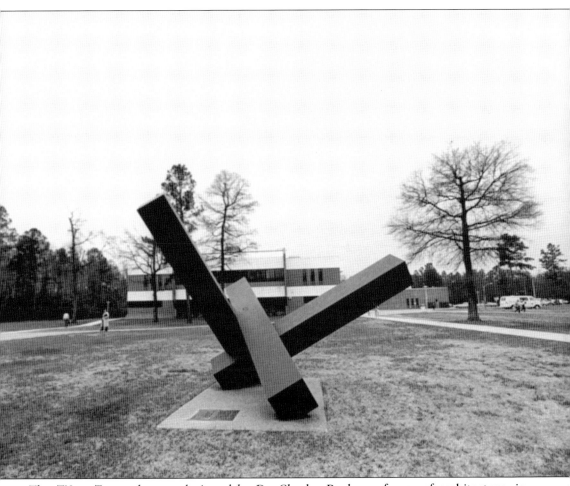

The *TN at Ten* sculpture, designed by Dr. Charles Bush, professor of architecture, is located in the center of the campus. Bush said of his creation, "I'm content to let others say what the sculpture is. To a child, it looked like French fries; to a philosopher, it looked like a Freudian phallic symbol. If I could say it with words, I wouldn't need to make a sculpture." The sculpture was designed by Bush and brought to life as an instructional project for welding students under the direction of Charles Hinton. Materials were acquired through a surplus equipment and supplies recycling program, and concrete for the base was donated by a local business. The sculpture was unveiled on October 8, 1978.

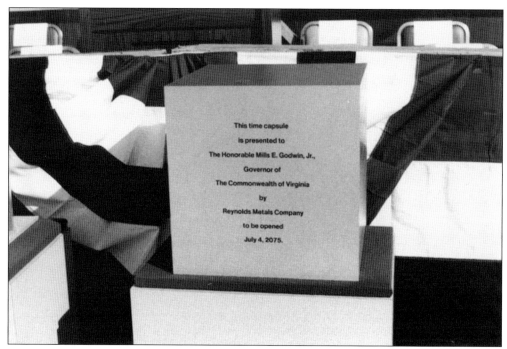

The dedication of this time capsule was held on April 15, 1977. The contents included photographs and lists of college staff, students, faculty, and administrators; aerial photographs of the campus; local department store catalogs and telephone books; copies of course catalogs; and the 1970 yearbook, *Impact*. It also contained bicentennial coins and predictions written by local mayors, doctors, fire and police chiefs, and representatives from NASA and the Daughters of the American Revolution.

This is the marker indicating the resting place of the time capsule. It is located next to the *TN at 10* sculpture in the courtyard of the Hampton campus. The time capsule is to be opened in 2078. (Photograph by Michael Wessel.)

GEN. THOMAS NELSON JR.
PATRIOT SOLDIER CHRISTIAN-GENTLEMAN
BORN DEC. 18 1738 DIED JAN 2 1789
MOVER OF THE RESOLUTION OF MAY 15, 1776
IN THE VIRGINIA CONVENTION
INSTRUCTING HER DELEGATES IN CONGRESS
TO MOVE THAT BODY TO DECLARE THE COLONIES
FREE AND INDEPENDENT STATES
SIGNER OF THE DECLARATION OF INDEPENDENCE
WAR GOVERNOR OF VIRGINIA
COMMANDER OF VIRGINIA'S FORCES

HE GAVE ALL FOR LIBERTY

Thomas Nelson Jr., the namesake of the college and a signer of the Declaration of Independence, served as a brigadier general during the American Revolution and, later, following in the footsteps of his friend Thomas Jefferson as governor of Virginia. This is the marker on Nelson's grave in Yorktown, Virginia. Early suggestions for the name of the college included simply calling the new institution "Peninsula Community College." The final decision was made after the Thomas Nelson Jr. Chapter of the Virginia Society of the Sons of the American Revolution donated funds to create the college's first scholarship. The scholarship established by the Thomas Nelson Jr. chapter is still presented to two students each year. (Photograph by Michael Wessel.)

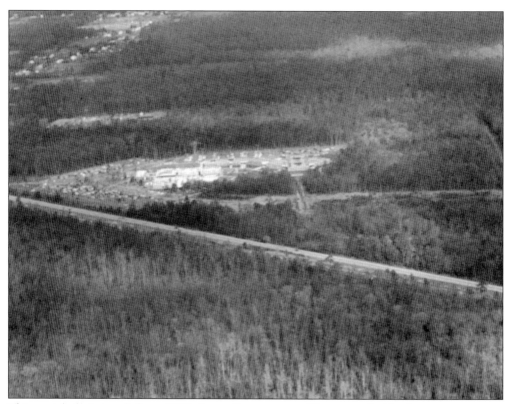

This aerial photograph from 1975 shows the campus still surrounded by forest.

The ground-breaking ceremony for Hastings Hall was held on May 19, 1978. Hastings Hall was originally going to be called David Jameson Hall in honor of Jameson, who served as a Colonial lieutenant governor. The name was changed in 1979 when a board motion was put forth by Ida Patrick to name the building in honor of Charles and Mary Hastings, of Teledyne Hastings Instruments, in recognition of their contributions to the college. Hastings Hall was dedicated on October 18, 1980. The $4-million engineering and natural sciences building became the only building on campus not named for a contemporary of Thomas Nelson. Pictured here are, from left to right, Dr. Dana B. Hamel, chancellor of the VCCS; Dr. Gerald Cannon, president of the college; Y.B. Williams, vice president of the Newport News Shipyards and Hampton city councilman; and Robert B. Smith, member of the Thomas Nelson local board.

Upon graduation from the nursing program, students are traditionally "pinned." This photograph was taken during a pinning ceremony at the Hampton campus in the 1980s.

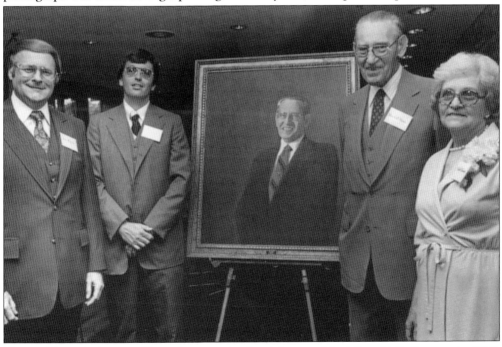

Pictured here is the unveiling of a portrait of retiring president Gerald O. Cannon in 1979. The portrait was painted by Tom Waters, TNCC art professor. Cannon joined the college as its first dean of instruction and later served as president of the college for seven years. Incoming president Dr. Thomas Kubala is pictured at far left. Cannon and his wife, Edith, are on the right. (Courtesy of the Daily Press Media Group.)

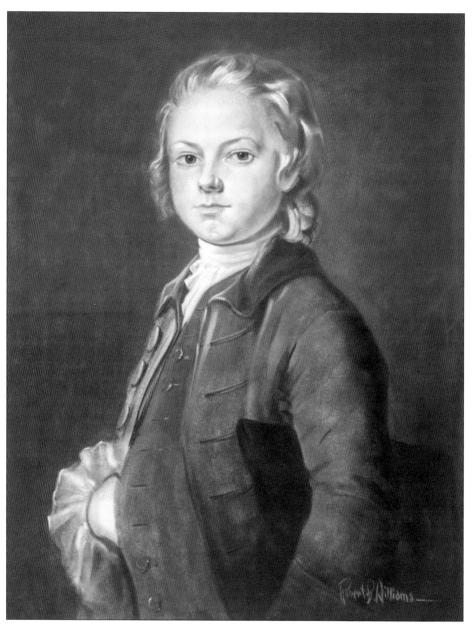

The only known portrait of Thomas Nelson Jr. was painted by Mason Chamberlayne in 1754, when Nelson was 16 years old and a student at Cambridge University. By the early 20th century, the painting was in the private collection of Dr. John Randolph Page of New York City, and in 1925, the Virginia Historical Society had a copy painted by Duncan Smith for its collections. In 1967, John P. Yancey Jr., a local businessman, commissioned a copy of the portrait as a gift to the college. This copy was done in pastel chalks by Robert B. Williams of Washington, DC, and presented by Yancey to the college on the occasion of the cornerstone-laying ceremony, after which it was to be permanently hung in the office of the president. "I want to wish for the Thomas Nelson College, its Trustees, Faculty, Personnel, and Students every good wish for a long and successful future," noted Yancey in a letter to President Jenkins on September 9, 1968. (Photograph by Michael Wessel.)

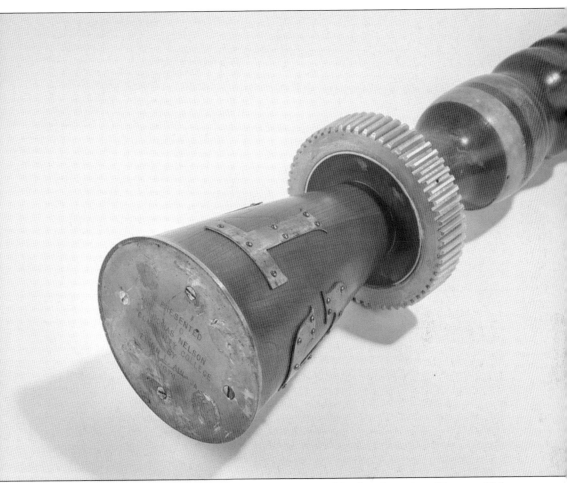

The ceremonial mace is a staple for all institutions of higher learning. Thomas Nelson is no different, and yet it is unique. The mace (of which the head is pictured here) was constructed by Thomas Nelson students and faculty. It reads "Presented to Thomas Nelson Community College by Elvin L. Ahl, Jr, 1974." Ahl was a student in the Engineering Technician program at Thomas Nelson during the mid-1970s and later an employee at the NASA Langley Research Center in Hampton. (Photograph by Michael Wessel.)

The cornerstone of the college is shown as it looked in 2017 during the 50th anniversary of the college. It is at the entrance to Harrison Hall, the college's administration building. The cornerstone was laid on December 15, 1967. On December 15, 2017, fifty years later to the day, the college commemorated the placing of the stone with a ceremony recognizing its significance. (Photograph by Michael Wessel.)

Two

GROWING WITH THE COMMUNITY

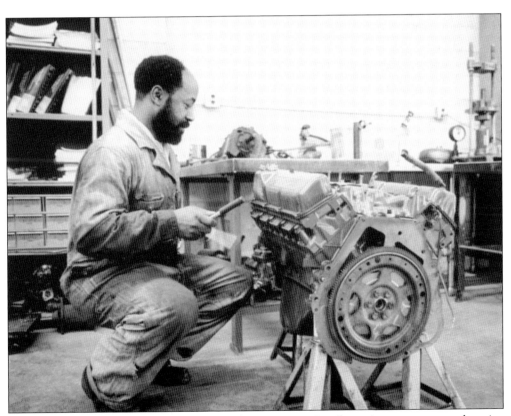

From the beginning, TNCC has served the Hampton Roads region as a comprehensive community college, offering general education and technical programs side by side. Students, like the one pictured here in 1979, take the classes they need to fulfill their particular ambitions.

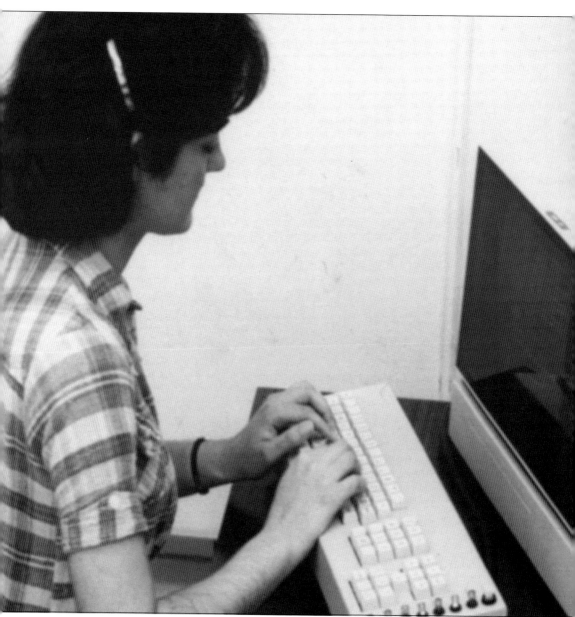

From the beginning of his term, TNCC president Thomas Kubala recognized the need for students' perspectives in college decision-making. "I'm happy to see a revival in student interest," he said in *The Nelsonite* of January 28, 1980. "Students are looking to assist in improving the image of the school and community. I hope this interest is contagious throughout the college."

A visionary leader, Dr. Thomas S. Kubala, the third president of TNCC, served the college between 1979 and 1986. "I'm my own man and I'm going to do what I think is right for Thomas Nelson," said Kubala in the February 20, 1979, edition of *The Nelsonite*. He continued: "I'd like to work together with people and not be bound by past policies." (Photograph by Michael Wessel.)

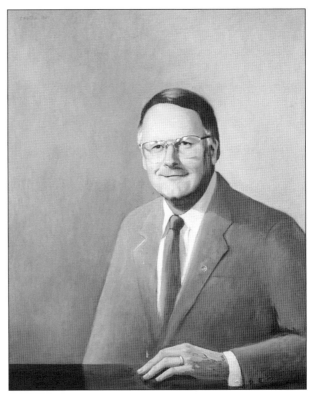

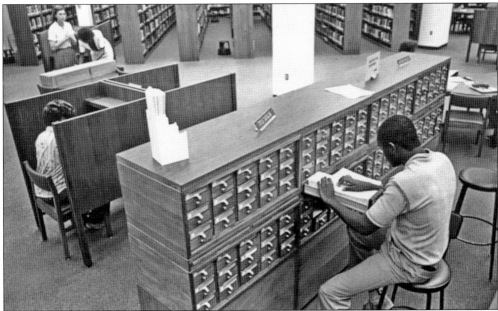

Though the methods and means of research have changed in the past 50 years, the Learning Resources Center at Thomas Nelson has always provided students with the necessary resources to find the information they need to be successful. Here, a student at the LRC in 1981 peruses the college card catalog, which provided details about the college's holdings by title, author, and subject. (Courtesy of the Daily Press Media Group.)

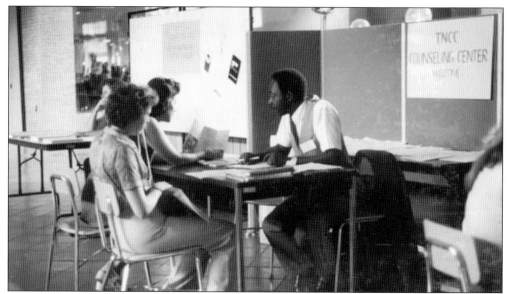

During the mid-1980s, Thomas Nelson took recruitment on the road, effectively meeting students exactly where they were both academically and geographically. In 1986, recruitment tables offering information on TNCC programming and services could be seen at the Coliseum Mall in Hampton.

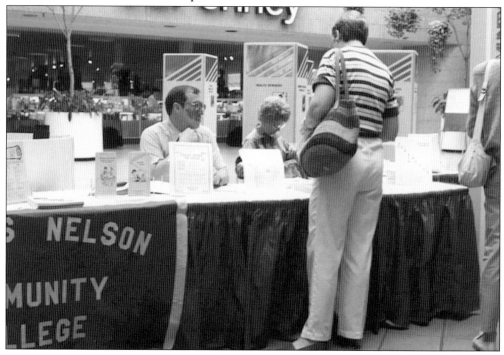

As with all of Virginia's community colleges, Thomas Nelson serves citizens from a particular region. The region of service for Thomas Nelson encompasses the cities of Hampton, Newport News, Poquoson, and Williamsburg, and the counties of York and James City. Seated at left is Dr. Howard Taylor, coordinator of the college's Counseling Center, talking with a prospective student.

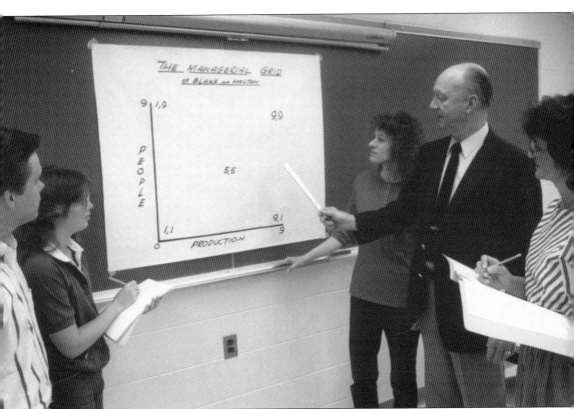

Management classes continue to be a strong component of the business curriculum at Thomas Nelson. Here, instructor Ted Drake is discussing the Blake-Mouton managerial grid. The concept was designed to help companies better align employee skills with job needs.

The Learning Resource Center at Thomas Nelson Community College initially took up the entirety of Wythe Hall. The center operated in a limited capacity before the construction of Wythe Hall but dramatically expanded its services after the completion of the new building. New services included innovations like a photography laboratory, a developmental television facility, and multimedia presentation rooms, along with a larger, more developed library. This photograph from the late 1970s shows the college library in Wythe Hall.

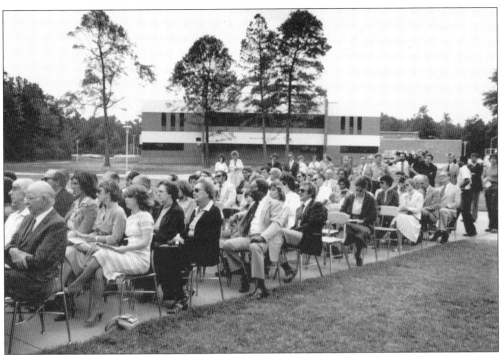

The Nelsonite reported on January 28, 1980, "TNCC's master plan for the new decade calls for physical and programmatic expansion to rival the giant strides made during the 70's. According to the plan, the 80's will see four new buildings and 23 curricula developed here." Hastings Hall was dedicated to serve the region in January 1980; the ceremony is pictured here.

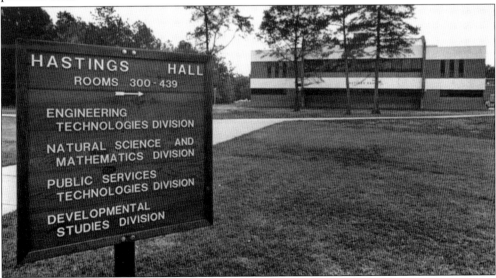

Hastings Hall, named after longtime peninsula residents and college supporters Charles and Mary Hastings, initially included laboratories, classrooms, and faculty offices for four college divisions: Engineering Technologies, Natural Science and Mathematics, Public Service Technologies, and Developmental Studies. The 62,000-square-foot, two-story facility opened for classes for the winter 1980 semester.

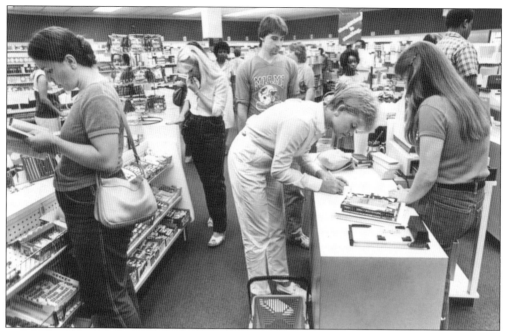

The caption for this photograph in the September 17, 1984, *Daily Press* read, "The Thomas Nelson Community College Bookstore is busy on the first day of classes." This marked the beginning of the fall quarter. All VCCS colleges operated on the quarter, rather than semester, system from 1966 until the mid-1980s.

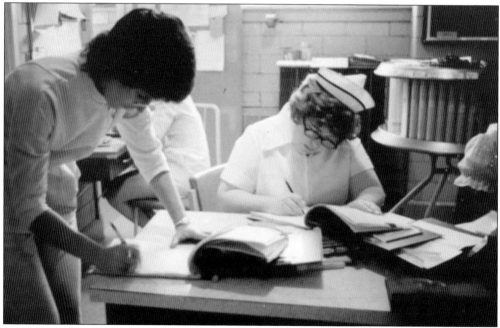

Soon after the community college system was established, the demand for health-related professions became clear. Nursing was the first health professions program established at Thomas Nelson. Admission to the program continues to be highly competitive. This photograph from the 1980s shows nursing students completing reports.

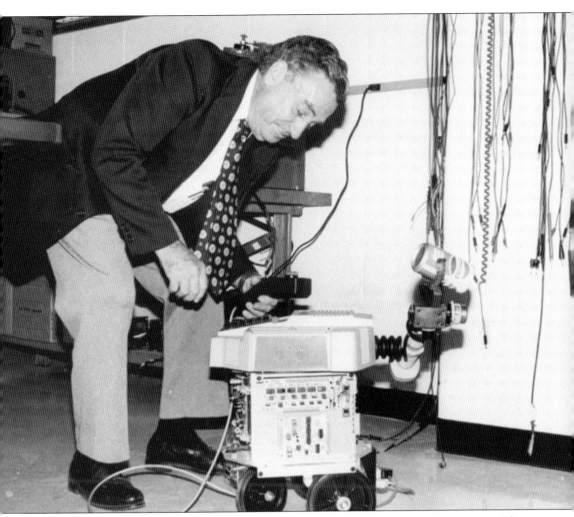

Technology has always been an important part of the TNCC experience. It was no accident that one of the first construction projects on the new campus was the construction of facilities that would offer students and faculty increased access to the latest technological resources. By the early 1970s, TNCC was spending about four percent of its annual budget on a computer center; this was well before computers were established or commonplace. Scenes like the one in this 1970s photograph were common in the early days of the college as faculty and staff embraced the use of technology as a teaching tool. Pictured here is engineering faculty member Cecil Dickerson.

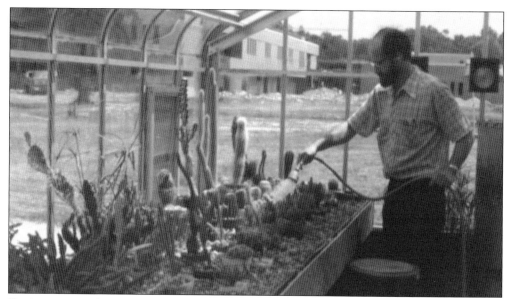

Having a greenhouse available to give students a hands-on approach to growing and cultivating plant and agricultural life was a priority from early in the college's history. The discussion began as early as 1969, and the foundation for the greenhouse was laid on June 24, 1970. The building was completed several months later in August 1970. After the construction of Hastings Hall in 1980, the original greenhouse shown in this photograph was dismantled, and a new one was constructed in the Hastings Annex. Pictured tending plants is Robert Auerbach, one of the college's original staff members. He was recognized in 2018 at the annual college awards ceremony for 50 years of service.

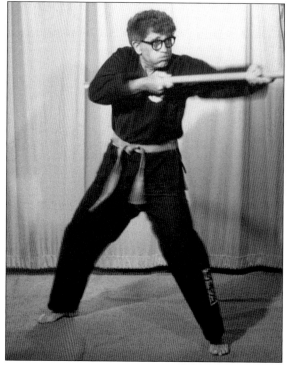

Over the years, many student clubs have been created, reflecting the diverse interests of the students. In this 1970s photograph, Dean of Student Services Tom Barrett practices with a *bo*, a six-foot-long staff-like weapon used in karate. Barrett held an orange belt, seventh promotion, and was a sponsor of the TNCC Karate Club.

According to an April 1980 *Nelsonite*, "The Word Processing Center receives handwritten documents from the administration and faculty and in three days returns that material, in a finished form, to the principal for final proofing and distribution. They also type the copy for *The Nelsonite* on the Compugraphic Editwriter 7300. They store a copy of all documents so that when the principal wants another 50 copies of form LRC-7 (in 15 minutes) the Word Processing Operators do not have to re-type the form."

This view of the TNCC campus, taken sometime in the 1980s from the front steps of Wythe Hall, highlights what were then the brand-new elements of the college. In the background sits Hastings Hall, which was finished in 1980. In front of it sits the sculpture *TN at Ten*.

TNCC has always offered courses in education to help prepare students who wish to later transfer and receive a bachelor's degree. Here, Hope Lanier works with children in a child development workshop on February 24, 1979, with members of the EDUC 137 class. The college catalog described EDUC 137 as a course designed to prepare individuals for working with children in art and other creative activities.

Over the years, Thomas Nelson has tried to simplify the registration process. The registration system went online (in a very limited sense) for the first time in the spring of 1978, when computerized systems were put in place to reduce human error, cut down on the time needed to identify conflicts, and generally streamline the process. This image of a long line stretching down the hallway from the 1980s may indicate that the system needed a bit more work.

There have been multiple iterations of college signs along the border with Interstate 64, which runs past Thomas Nelson Community College. The first one was installed in the spring of 1971 as a means of promoting interest and awareness in the fledgling college. The sign shown here is the second version but was widely disliked around campus due to a near-constant need for maintenance. After being declared "tired and decrepit" in 1995, this sign was replaced by a newer, more visible sign as part of a larger construction project.

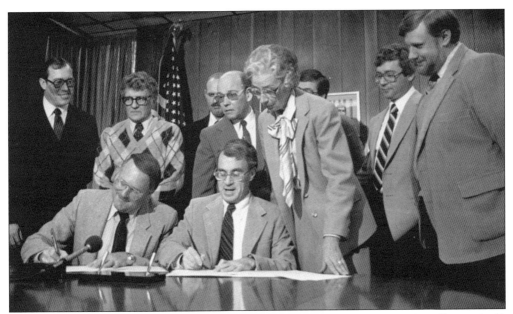

In 1982, Thomas Nelson Community College and Christopher Newport College (CNC) signed an 18-program transfer agreement. While limited transfer agreements already existed with CNC and other colleges, this agreement was unique in that it was program-based rather than course-based. Dr. Thomas Kubala (seated at left), Thomas Nelson president, and Dr. John E. Anderson, CNC president, are shown signing the agreement as members of the Thomas Nelson and CNC administrations stand behind them.

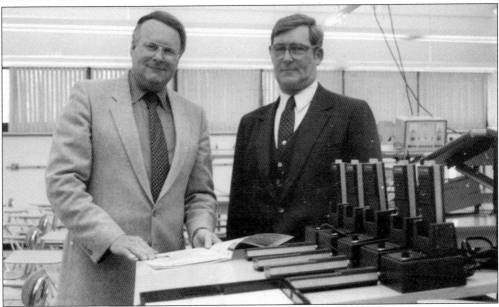

Donald E. Rump, district service manager for Motorola Communications and Electronics Inc., is pictured here with President Kubala and radio equipment being donated to the college. The value of the equipment was estimated at $13,000 and included 10 portable radios, 10 batteries and chargers, and the Audio-Visual Training Program (MAV-PAK) for the equipment.

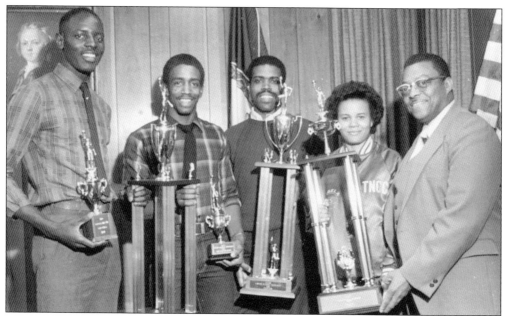

Basketball at TNCC began in the late 1970s as a club sport. It later became an official college team sport. This photograph from the early 1980s shows, from left to right, William Moore, Henry Bond, Claude Burton, Angela Jackson, and Eugene Johnson, chairman of the Thomas Nelson Community College local board, displaying—with great pride—the trophies TNCC won in the men's and women's Eastern Regional Basketball Tournament and the Rappahannock Invitational Basketball Tournament.

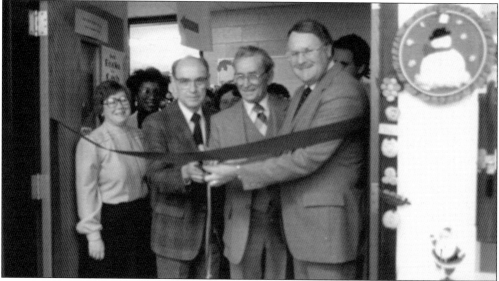

The grand opening of the renovated bookstore in Griffin Hall was held on December 7, 1983. The renovation added approximately 1,500 square feet and cost $143,000. The local firm of Evans Hudson Vlattas were the architects. Pictured in the front row from left to right are bookstore manager Mary Brennan, who acted as hostess for the ribbon cutting; Col. Nathan Cooper, chair of the local college board; T. Melvin Butler, president of the Thomas Nelson Educational Foundation; and Dr. Thomas Kubala, president of the college.

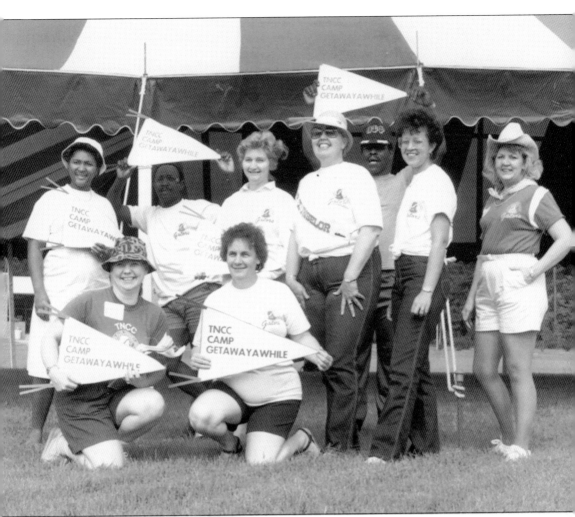

"Camp GetAwayAWhile" was the theme of the second annual summer program for area women. The event, created in 1985 by Dr. Pamela Turner and Dr. Christie Vernon, was officially called Summer Getaway for Women. It was a single-day summer camp involving some 70 campus volunteers. Its goal was to discuss serious issues confronting women through fun experiences. The participants could choose from more than two dozen workshops, with subjects ranging from aerobics and self-defense to career planning, wine tasting, cosmetics, sailing, and the use of microcomputers in the home. Four follow-up programs were offered at later dates, including Building Self-Esteem, Personal Career Interest Assessment, Personal Life-style and Skills Assessment, and Personal Packaging, which dealt with resume writing.

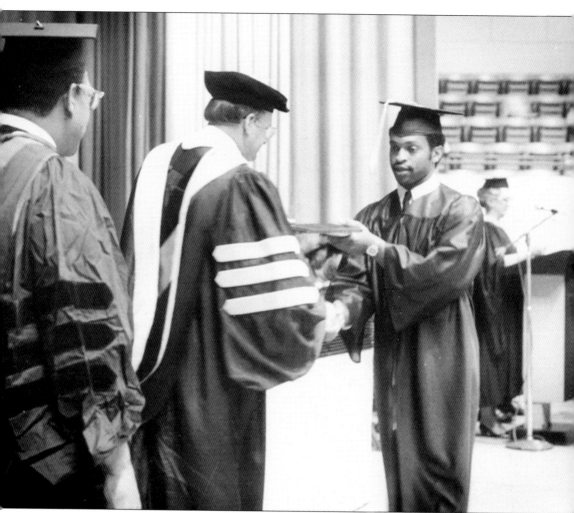

Commencement is the most wonderful time of the year for TNCC faculty, staff, and especially students. Shown here is President Kubala handing a diploma to a newly minted college graduate.

Three

MEETING THE NEEDS OF THE NEW MILLENNIUM

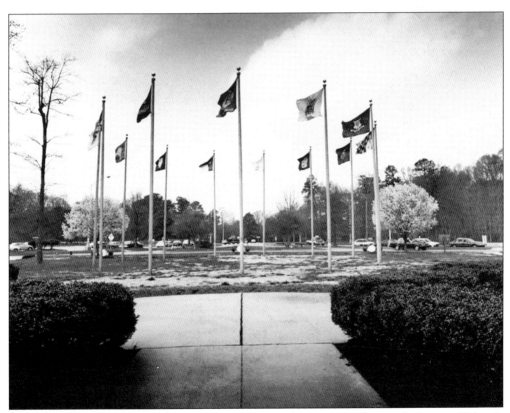

The Circle of Flags at the entrance to the college has remained one of Thomas Nelson's most recognizable features. This photograph, looking out from the doors of Harrison Hall, was taken in 1987. (Photograph by Barbara Dorr.)

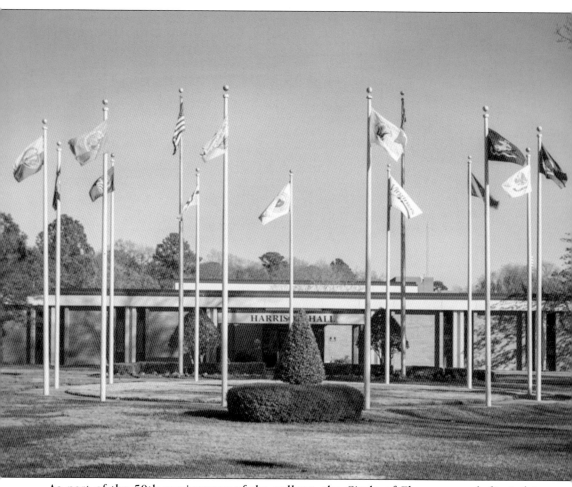

As part of the 50th anniversary of the college, the Circle of Flags was rededicated in December 2017. Flags representing the original 13 colonies, now states, will fly during the first week of each month. Another set of flags from each of the localities served by Thomas Nelson, the branches of the military, the Virginia Community College System flag, and the TNCC flag will fly at all other times.

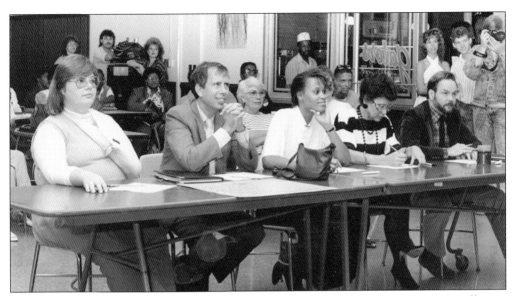

A student talent competition was held in November 1987. Students, faculty, and staff were treated to a variety of talents ranging from singing to dancing to juggling. The winner was C. Lynn Jenkins, who performed her interpretation of the Middle Eastern art of belly dancing before the stunned audience. Other winners included Latisha McCaulley, who took second place for an interpretative dance set to Janet Jackson's "Control," and three third-place prizes: Joseph Nguyen for playing "Ballade Pour Adeline" on the piano, Marcia Brown for singing Whitney Houston's "The Greatest Love of All," and Christopher Tucker and Joseph Walden for an original rap. The judges for the talent show pictured here are, from left to right, Keri Harris, Dr. Robert G. Templin Jr., Stephanie Parker, Adrienne East, and Mike Bruno.

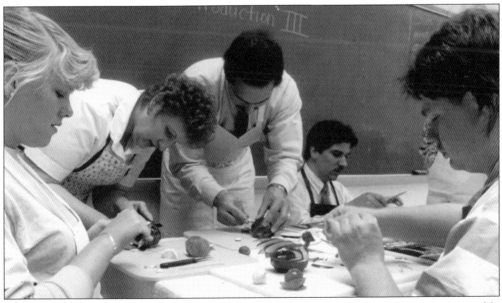

TNCC students in Food Production III learned the ins and outs of proper vegetable peeling. The three-quarter Food Service Management program addressed the need to update employees in food service positions in public schools and food service institutions.

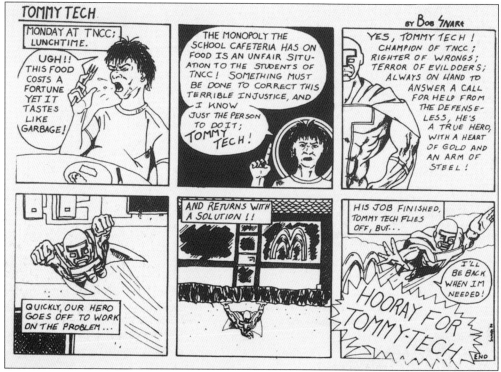

The college's early nickname of "Tommy Tech" was personified as a superhero in several issues of *The Nelsonite*. This sample from 1986 lampoons a perennial issue at the college (as at most colleges)—the quality of food in the student cafeteria. (Used by permission of the artist.)

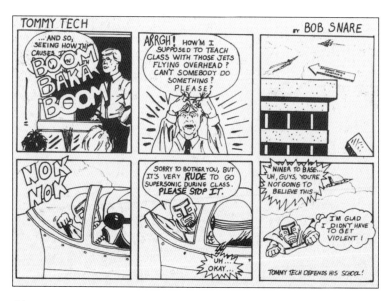

The site of the Hampton campus is under the flight path for Langley Air Force Base, resulting in near-constant jet noise. (Used by permission of the artist.)

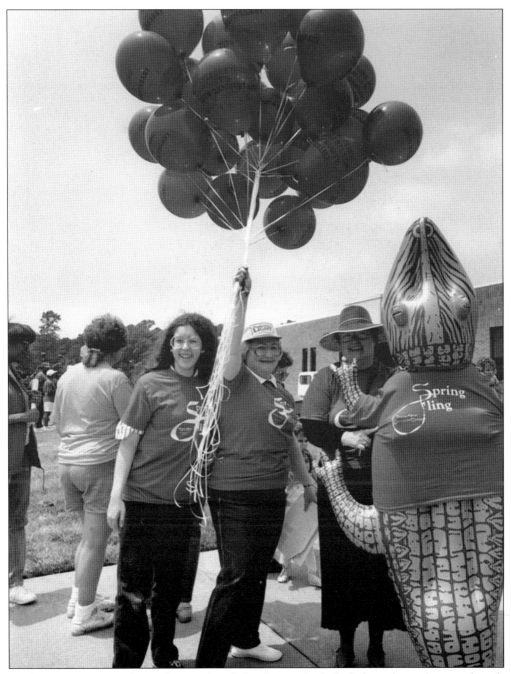

At the 1988 Spring Fling, the Battle of the Deans included three-legged races, beach volleyball, hacky sack, and games like horseshoes, backgammon, Trivial Pursuit, and pinochle.

Soon after the college opened in 1968, the college board decided that a sign visible from interstate 64 was needed. The board chose a brick masonry design to complement the look of the college buildings. A December 11, 1970, article in the *Times-Herald* stated, "Travelers on interstate 64 will soon be informed the cluster of modern brown brick buildings they're passing is Thomas Nelson Community College." The new sign was completed in the spring of 1971. This promotional photograph shows Pres. Robert G. Templin and a group of students standing behind the sign shortly before it was replaced as part of a wider campus renovation in 1995.

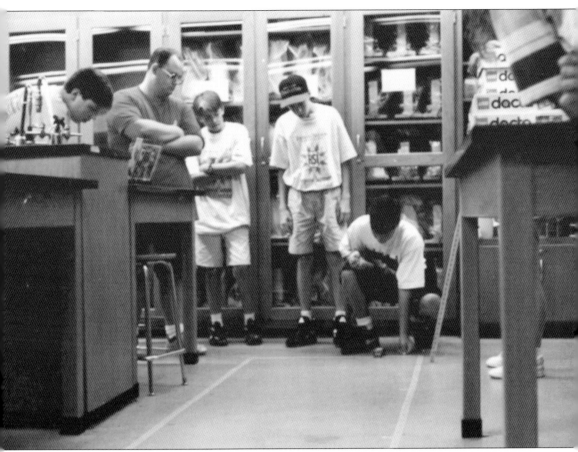

In 1990, the college began hosting a four-week Regional Summer Math and Science Institute for peninsula middle school students. Students participated in a variety of activities, including math, physics, chemistry, biology, and technology. Cooperative learning, team competitions, hands-on intensive activities, and innovative teaching methods were incorporated into the program.

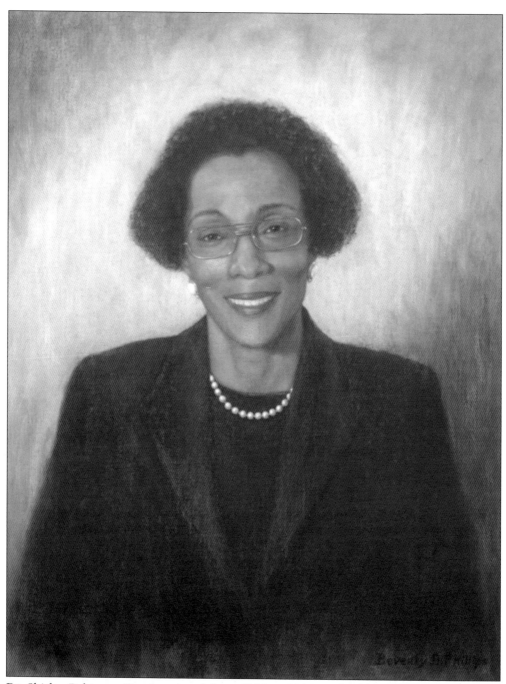

Dr. Shirley Robinson Pippins served from 1995 to 2003 as the fifth president of Thomas Nelson Community College. Her portrait, painted by retired TNCC professor Beverly Phillips, hangs in the Moore Hall Gallery. (Photograph by Michael Wessel.)

President Pippins was a highly visible presence at the college. Here, Pippins, second from left, is shown engaging with faculty during a monthly faculty meeting.

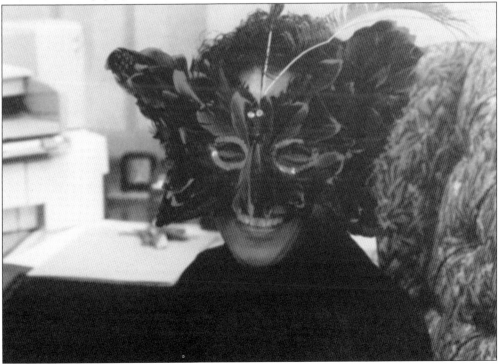

President Pippins had a remarkable sense of duty but also a contagious sense of humor. She is pictured wearing a mask for Halloween in 1997.

Plans to expand the college's services into Williamsburg began within a few years after the Hampton campus opened. In 1978, the college began offering classes at Bruton High School, Eastern State Hospital, the Williamsburg Police Department, and the James City County office building in Toano. Programs included police and fire science and hotel and motel management. In 1998, the college established a more permanent location by renting several office suites in John Jefferson Square in Williamsburg.

TNCC faculty and students know that one needs to mix in a little play with work. This 1998 photograph shows some of the participants and facilitators of the first-ever Limerick Contest held at the college. The contest, held on St. Patrick's Day, was jointly put on by the Cultural Activities Committee and the Student Activities Office. The first year featured 76 entries, with Helen Weddle taking first place with a limerick entitled "Additional Thoughts on Victorian Marriages." Pictured from left to right are Ellis Long, Gerry Safko, Mike Bruno, Bette Thomas, and Jean Gordick.

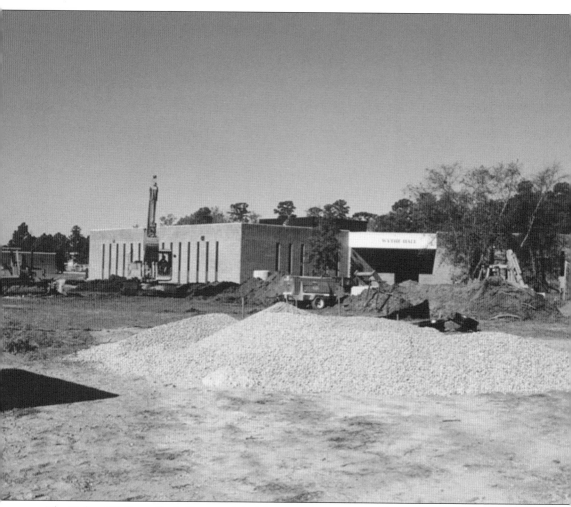

The Robert G. Templin Jr. Instructional Support Services Building, later known as Templin Hall, was a major building project for Thomas Nelson in the late 1990s. Dr. Templin, the building's namesake, served as the college's president for eight years from 1986 to 1994. The building took almost exactly three years to build, with the dedication ceremony occurring on October 30, 2002.

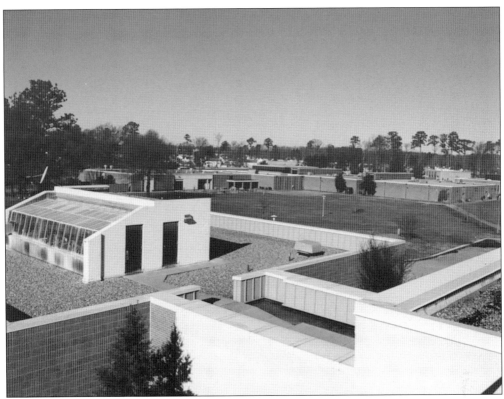

The Hampton campus of TNCC has expanded considerably beyond its three original buildings. Early enrollment numbers from 1968 onward quickly proved that expansion was necessary, and by 1971, the state board had already given its support for 12 proposed new buildings. This picture was taken in 2000 from the roof of Hastings Hall, on which construction began in 1978.

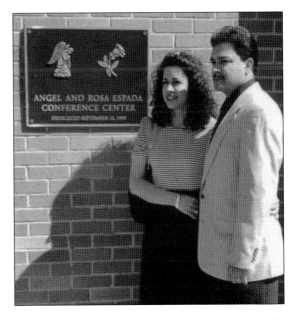

In the early 1990s, alumna Carmen Hart began making donations to the Thomas Nelson Educational Foundation. Initially, these were in the form of scholarships, but she subsequently added other forms of student aid. Her donations eventually exceeded $100,000. In thanks for her generosity, the foundation offered to rename the recently renovated conference room in Moore Hall after her. However, Hart chose to instead have the center named for her parents. They had died within a few weeks of each other, and she wished to memorialize them, so the new convention center became the Angel and Rosa Espada Conference Center. Hart is pictured with her husband, Jeffrey, next to the dedication plaque.

73

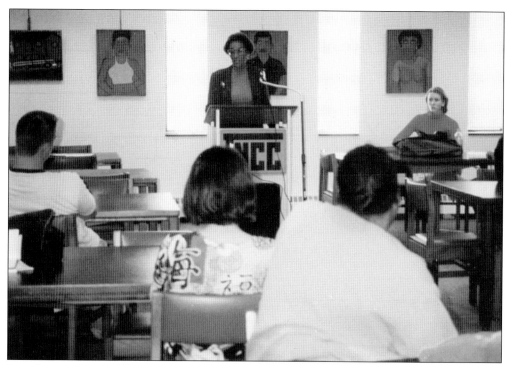

President Pippins addresses a meeting of students and faculty in the Wythe Hall Library Gallery. Such meetings were not uncommon for Dr. Pippins.

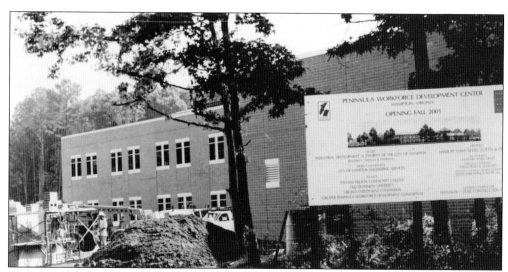

The Peninsula Workforce Development Center is a joint venture between TNCC, Old Dominion University, the Virginia Employment Commission, and the Greater Peninsula Workforce Development Consortium. It was constructed using funds from every peninsula jurisdiction with support from the Virginia state legislature. The center trains peninsula workers to be competitive at a global scale in a wide variety of technical positions. This image shows the center shortly after its ground-breaking ceremony in the summer of 2000.

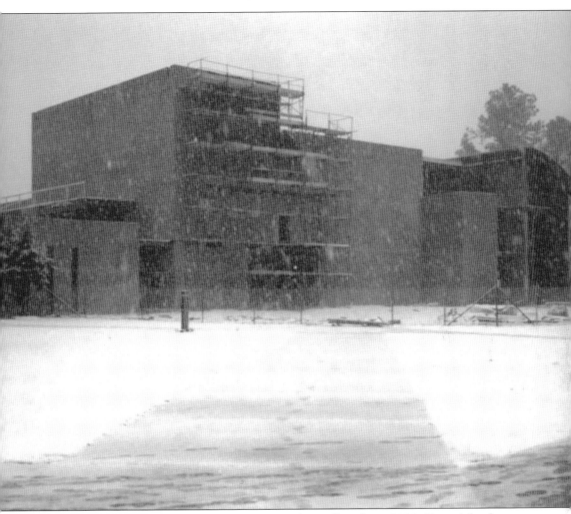

This snowy view of the nearly completed Templin Hall is from 2001. Named for former president Robert G. Templin Jr., who served from 1986 to 1994, Templin Hall was the first academic building added to the campus since the completion of Hastings Hall in 1980. The nearly 50,000-square-foot building was added as instructional support services space and featured campus improvements like a 470-seat auditorium, wardrobe and practice rooms, computer classrooms, a language lab, an audio-visual production area, and a multimedia distribution center.

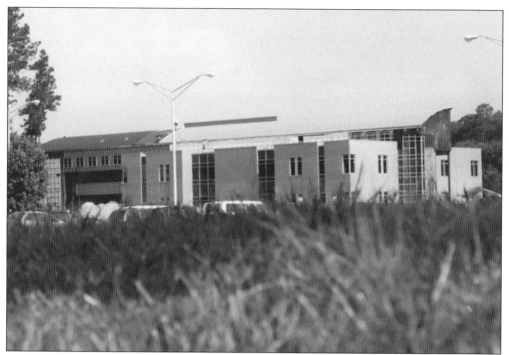

This 2001 photograph shows the newly completed Templin Hall.

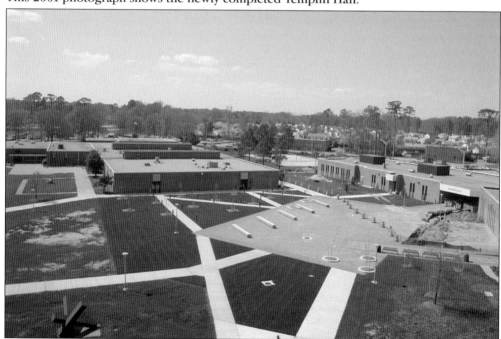

During 2001 and 2002, in addition to the construction of Templin Hall and the Peninsula Workforce Development Center, the campus courtyard underwent a substantial renovation. New drainage, lighting, and irrigation systems were installed, and an exterior doorway was added in the Griffin Hall cafeteria that opened onto a new raised terrace where students, faculty, and staff could dine and relax outdoors.

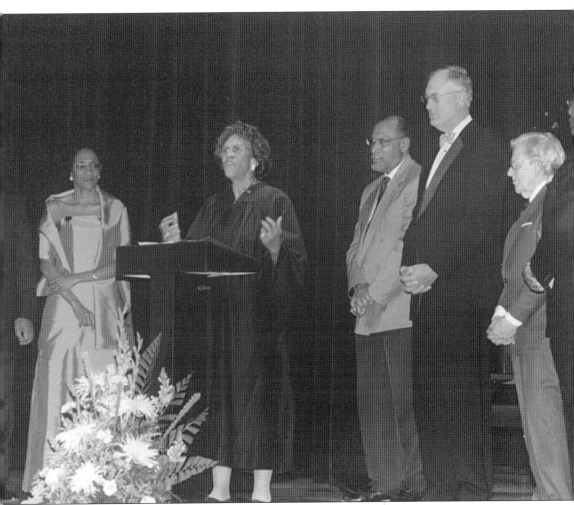

The auditorium in Templin Hall was named in honor of Dr. Mary Taylor Christian, a local educator, delegate, and community leader. The theater was dedicated with a gala celebration on January 15, 2003. Christian was born in Hampton in 1924, one of five children in a household where money was scarce but the value of education was instilled. She began her academic career at Hampton Institute (now Hampton University), earning a bachelor's degree in education in 1955. She taught in Hampton city schools while earning a master's degree from Columbia during the summers, then taught at Hampton University while earning a doctorate from Michigan State. Christian was the first African American to serve on the Hampton City School Board and became the first woman from Hampton elected to the state legislature. She served nine consecutive terms representing Virginia's 92 House District, where she championed legislation centered on health care and education.

Templin Hall features a 470-seat performance hall complete with orchestra pit, dressing and rehearsal rooms, and state-of-the-art lighting and sound systems. It is also home to over two dozen faculty offices.

Dr. Robert G. Templin Jr., the fourth president of Thomas Nelson Community College, served from 1986 to 1994. Templin's portrait, created by O'Neal Studios, hangs in the Moore Hall Gallery.

Four

GROWING BEYOND HAMPTON

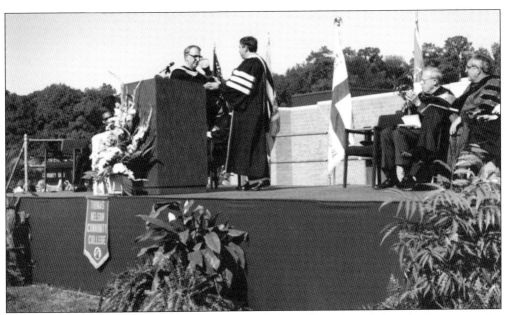

Howard G. "Duddy" Forrest Jr., chairman of the college board, hands the mace, the symbol of the power vested in the president, to Dr. Robert G. Templin Jr. during his inauguration as the college's fourth president. The ceremony was held on October 24, 1987, in the campus courtyard and attended by the college community and a variety of distinguished guests including two of Thomas Nelson's three previous presidents and Virginia senator Hunter Andrews. Templin was appointed president in 1986. In keeping with Virginia community college tradition, the president is inaugurated one year following their appointment to the office. In his address, Templin said, "As Thomas Nelson Community College enters its third decade of service to the people of the region, my hope is that it will be increasingly regarded as the area's college of opportunity."

The college's 20th anniversary was celebrated with a Sunday afternoon garden party at the Nelson House in Yorktown on May 22, 1988. This celebration also commemorated the 250th birthday of Thomas Nelson Jr. A local artist, Chee Kludt Ricketts, was commissioned to create pen-and-ink drawings of both the Nelson House and Harrison Hall, with the Circle of Flags, which were printed and distributed to guests. Matt Riebe, the actor who portrayed Thomas Nelson at the Nelson House, so impressed attendees that he was later hired to do a series of promotional photo shoots on the Hampton campus.

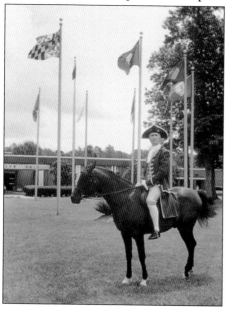

On June 7, 1989, the college staged a promotional photo shoot featuring Matt Riebe, the actor who portrayed Thomas Nelson Jr. at the Nelson House in Yorktown. Riebe was joined by Nookie, a stallion belonging to Pat Rock, associate professor of medical laboratory technology. The day's video was used for television commercials, and still images graced the cover of the college's course catalog for the following academic year.

Gov. Gerald Baliles addresses the college community on May 23, 1988, for the kickoff of his administration's sixth regional "work week." The governor and his staff were in residence for three days, taking over most of Harrison Hall and displacing Pres. Robert G. Templin to the personnel office.

Instructor Jerry Morris is shown working with a student in the college Wellness Center, which opened in January 1993 in the Hastings Annex. Four renovated classrooms were outfitted with treadmills, stationary bikes, and other cardio equipment as well as strength-building machines and free weights. The center was used for physical education classes and was also available for several hours a day for use by faculty, staff, and students.

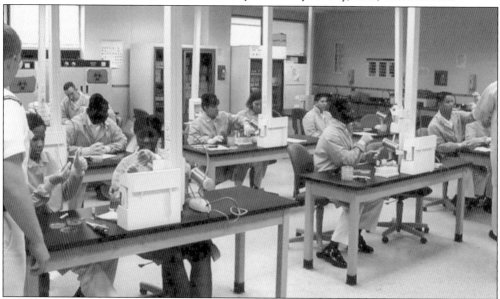

In 1999, the college signed a $1-million, two-year contract with the US Navy to train medical laboratory technicians. The partnership started as an experiment to see if the service could save money through outsourcing training activities. The Med Lab program was rigorous and provided students with the opportunity to earn 60 credits in one year.

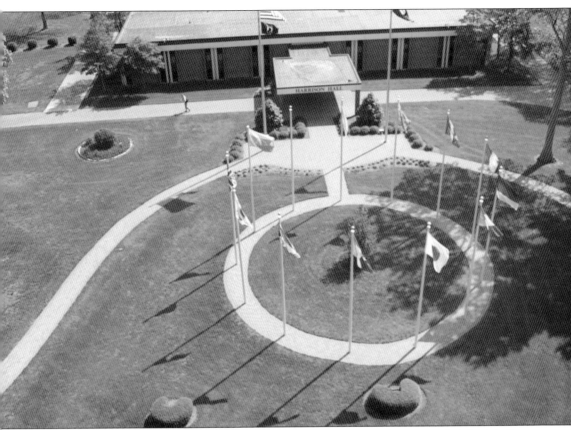

In 1998, a rotating collection of international flags replaced the original Colonial flags in the Circle of Flags. This was seen as a symbolic move toward a more global, forward-looking perspective. This new set of flags primarily consisted of countries with direct ties to peninsula localities, such as US trading partners and those that contained sister cities.

Dr. Charles A. Taylor served as the sixth president of Thomas Nelson Community College, from 2004 to 2009. This portrait hangs in the Moore Hall Gallery. (Photograph by Michael Wessel.)

In 2007, TNCC began a partnership—An Achievable Dream Academy—to establish the Southeast Higher Education Center in Newport News. This new venture was also supported by Newport News Public Schools, Riverside Medical Group, Northrop Grumman, and Ferguson Enterprises to provide educational opportunities through evening and weekend courses to adult learners in the community. During opening ceremonies for the academy, TNCC president Dr. Charles A. Taylor said, "We firmly believe that as part of the community, Thomas Nelson must remain committed to increasing our citizens' knowledge, improving their skills and boosting their earning power. All of these components go toward ensuring the economic vitality and future of the Peninsula."

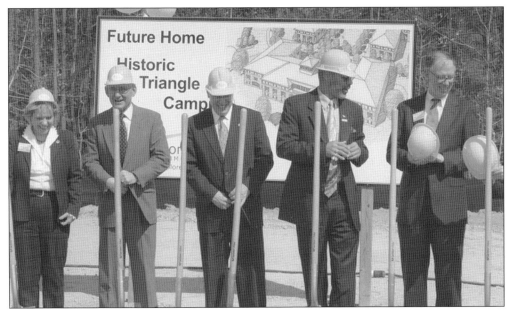

According to the 2009 TNCC annual report, "The new campus will be situated on nearly 74 acres at the Warhill site in James City County neighboring the region's newest high school. . . . The ground breaking was a milestone for the College and the citizens of Williamsburg, James City County and upper York County. A permanent campus in the area will enable the College to expand educational opportunities for those living and working in Historic Triangle communities." From left to right are the Hon. Melanie Rapp Beale, state senator Thomas K. Norment, unidentified, President Taylor, and James City County supervisor John McGlennon.

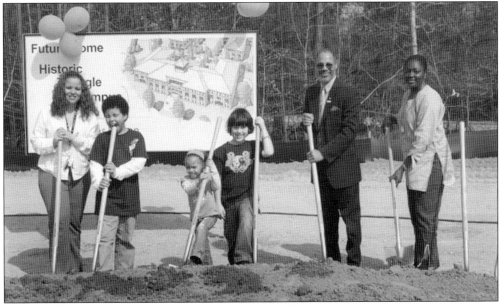

Along with state and local representatives and officials, college faculty and staff and members of the community turned out en masse for the Historic Triangle ground-breaking ceremony and were invited to participate with shovels.

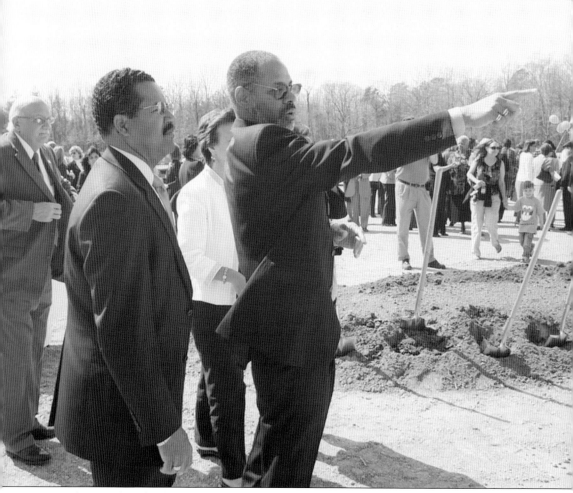

President Taylor shows Dr. McKinley Price, chair of the local college board, around the construction site for the new campus. Dr. Price was later elected mayor of Newport News. The Historic Triangle campus today is home to its Dental Hygiene program. To date, all the program's graduates have passed their national board exams and procured employment upon graduation.

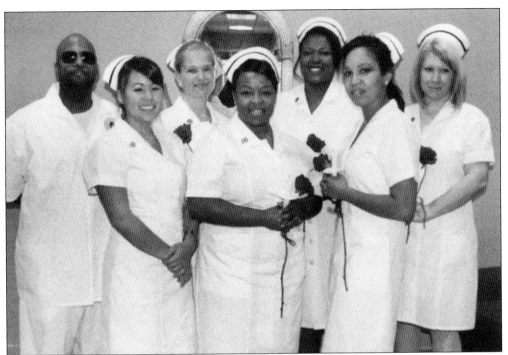

According to the 2007–2008 annual report, Thomas Nelson began offering nursing at its Historic Triangle campus in 2006, aided by a grant from the Williamsburg Community Health Foundation. These eight students were the first to complete the associate of applied science in nursing degree from the college's Historic Triangle campus. During the pinning ceremony pictured here in December 2007, the students recited the Nightingale Pledge, named for nursing pioneer Florence Nightingale.

"We strongly believe that access to quality education empowers people and improves their quality of life," wrote President Taylor in the 2007 annual report. "The accessibility Thomas Nelson Community College affords creates opportunities for our students to learn more whereby they can earn more."

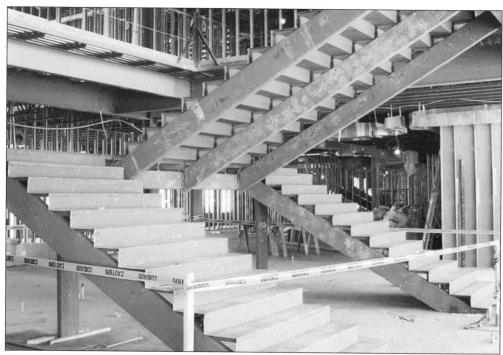

The current building that houses the Historic Triangle campus includes some 126,000 square feet. At the main entrance is a glass and steel structure known as the "grand staircase." In this photograph taken during construction, the girders that support the staircase are visible.

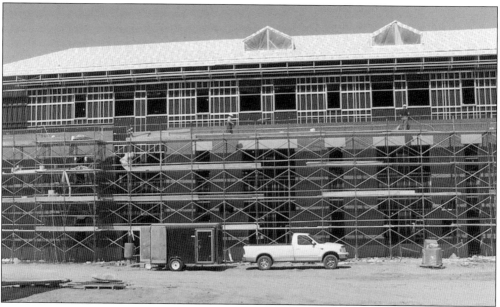

The Historic Triangle campus is just north of Williamsburg in the town of Lightfoot. Formerly known as Kelton, Lightfoot borders James City and York Counties. This photograph, taken during construction, shows the new campus minus its steel roof and signature cupola.

This photograph was taken on Constitution Day in 2009. A student takes the opportunity to encourage voter registration at the Hampton campus.

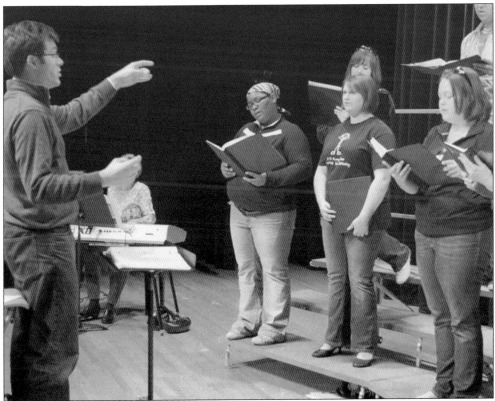

Performing arts have become one of the signature programs at Thomas Nelson. The department produces multiple concerts, musicals, and dramatic plays each year. Here, Michael Sundblad, chair of the Performing Arts Department, conducts the choir in preparation for an upcoming concert.

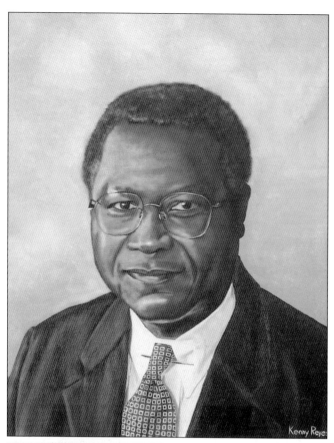

Dr. Alvin J. Schexnider served as the seventh president of Thomas Nelson Community College, from 2009 to 2011. This portrait hangs in the Moore Hall Gallery. (Photograph by Michael Wessel.)

As president, Schexnider brought a tremendous amount of leadership experience to the position. Here he is shown at a leadership seminar at the Peninsula Workforce Development Center on the Hampton campus.

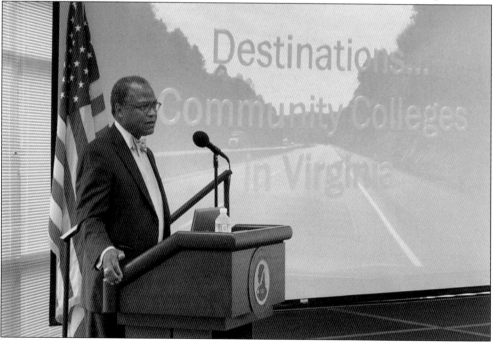

In this photograph taken at the Peninsula Workforce Development Center around 2010, President Schexnider is standing. Seated at far left is Thomas Nelson Community College business faculty member Bryan Jones; to his left is Dr. Glenn Dubois, chancellor of the Virginia Community College System.

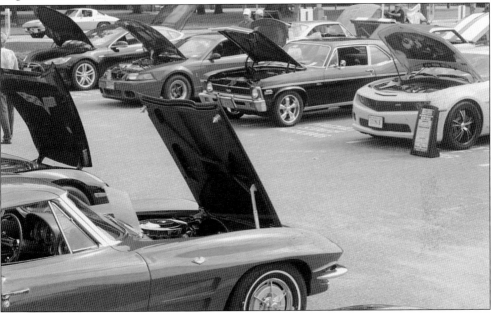

The college held its first car show in the summer of 2009, inviting enthusiasts from throughout the region to showcase their prized rides. Cosponsored by local businesses, this annual event features more than 30 classes including Chevrolet, Chrysler, and Ford classic and antique cars, trucks, tuners, and motorcycles, as well as late-model muscle cars. Proceeds from the fundraising event benefit the Automotive Technology Program and its students. An automotive training program certified by the National Institute for Automotive Service Excellence, the program provides entry-level instruction for aspiring mechanics and serves the continuing education needs of trained mechanics. Day and evening courses allow students to hone their skills on makes and models they are likely to see once they are hired as mechanics. TNCC has partnered with local dealerships to provide co-ops for students that include tuition assistance and assistance with job placement.

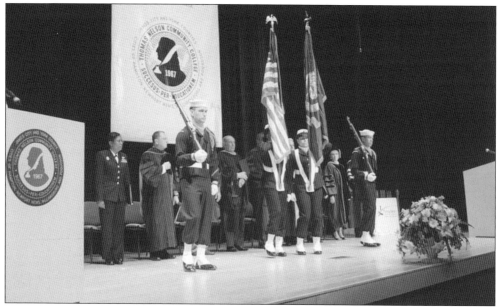

For 50 years, TNCC has proudly served military students, their families, and the country's veterans. In January 1999, the US Navy granted TNCC permission to serve enlisted sailors in the Medical Laboratory Technician program. This program prepared sailors to serve patients in laboratory settings across the world. Six months of classroom teaching followed six months of clinical training supported by TNCC mathematics, chemistry, and biology faculty. By academic year 2015–2016, 28 percent of the college's credit students indicated a military affiliation, and the college was listed among *G.I. Jobs* magazine's "military-friendly schools" for 2015.

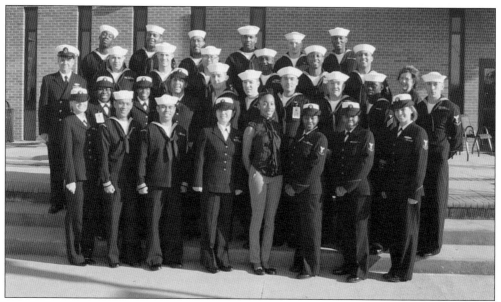

TNCC is proud of its ranking as one of the nation's most military-friendly schools. Approximately a quarter of Thomas Nelson students are either veterans or active-duty military. Pictured is a graduating class of the Medical Laboratory Technician program.

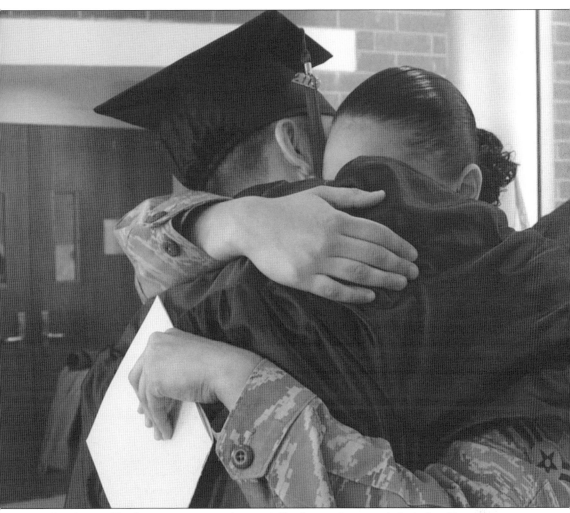

For faculty, staff, administration, and especially the students and their families, the most rewarding and exciting event at TNCC is the awarding of a degree or certification. Pictured here is an active-duty family member embracing a new graduate.

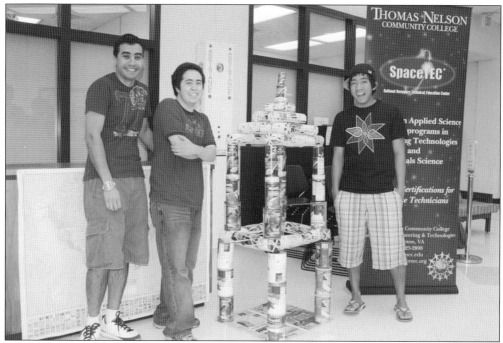

"Can-struction" is an annual contest sponsored by the Peninsula Food Bank, with the goal being to build the tallest freestanding structure from a specified number of cans, which are later donated to the food bank's stores. This 2008 photograph shows the winning entry and its designer-builders from TNCC's engineering classes.

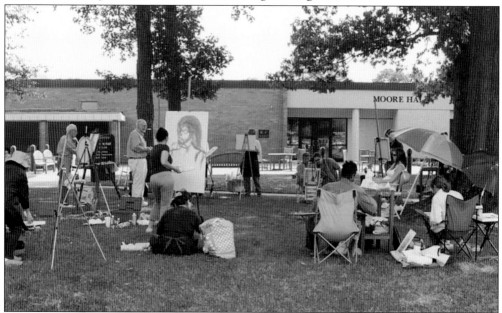

Art classes remain a popular offering at Thomas Nelson. In this 2009 photograph, an art class takes advantage of wonderful weather to find their inspiration outdoors. With the proliferation of computers over the years, Thomas Nelson has developed courses in graphics and computer art alongside more traditional art classes.

TNCC has had a long and mutually beneficial relationship with NASA Langley Research Center, which is adjacent to the TNCC campus in Hampton. NASA-Langley and Thomas Nelson have collaborated on a number of programs, such as the SPACE-TEC program, which allows students to explore a career in aerospace technologies.

Named "Gilbert" by students, the gator mascot endures into the 21st century and has been made manifest as a costumed character who appears at official and unofficial events on and off campus. Club, competitive, and intramural sports teams for both men and women now include baseball, basketball, soccer, volleyball, softball, golf, and bowling.

Five

THE PENINSULA'S COMMUNITY COLLEGE

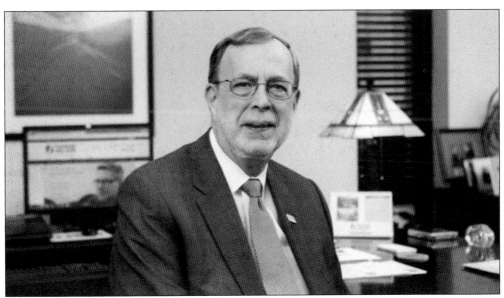

Dr. John T. Dever is currently serving as the eighth president of Thomas Nelson Community College. His tenure began in 2011. Prior to serving as president, Dever served in executive positions at Blue Ridge, Tidewater, and Northern Virginia Community Colleges. He began his community college career as a member of the English faculty at TNCC during the mid-1970s.

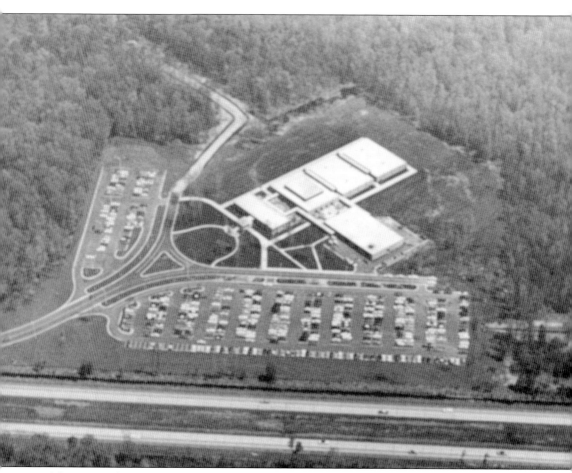

Thomas Nelson's Hampton campus has undergone steady growth throughout its first half-century. This photograph shows the campus when it opened in 1968. Shown are the original buildings of Harrison, Moore, and Diggs Halls. Note the lack of neighborhoods, which now surround the campus. Today, Diggs Hall serves as the home for the academic division offices for business, information systems, public services, and mathematics. (Courtesy of the Daily Press Media Group.)

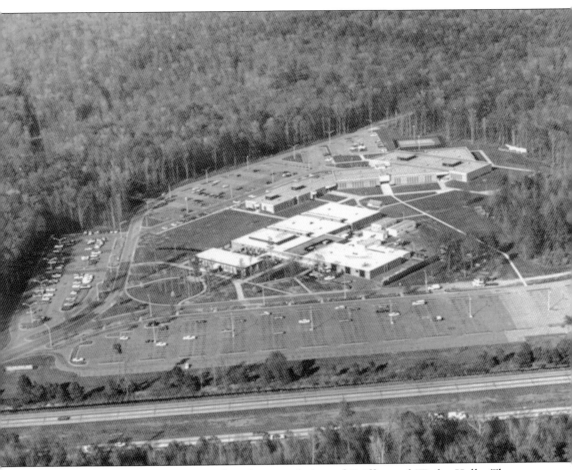

This 1976 photograph was taken after the completion of Griffin and Wythe Halls. These adjoining buildings sit just northeast of the original Harrison, Moore, and Diggs Halls. Today, located in Griffin Hall are student registration, financial aid, and advising. Wythe Hall contains the library, IT and the IT Helpdesk, and Student Activities. (Courtesy of the Daily Press Media Group.)

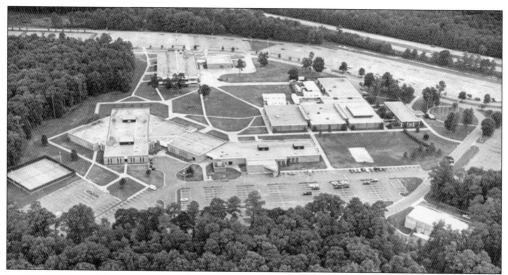

In this 1986 aerial photograph, the recently constructed Hastings Hall is visible. Hastings Hall is adjacent to Wythe Hall. Hastings is home to the Academic Division of Science, Engineering and Technology. The building consists of specialized classrooms and computer labs to support the various curricular needs of that division. (Courtesy of the Daily Press Media Group.)

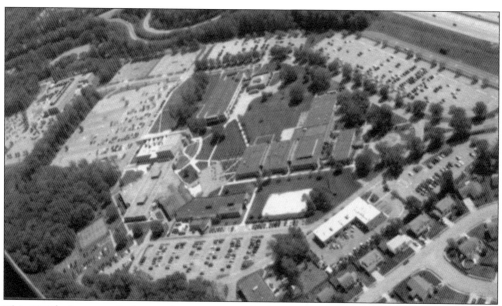

This 2004 photograph shows the campus with the addition of Templin Hall. Located next to Hastings Hall and connected to Wythe Hall, Templin is home to the Mary T. Christian Auditorium and the Performing Arts Department, consisting of music, art, and theater. It is also home to the Academic Division for Communications, Humanities and Social Sciences. (Courtesy of the Daily Press Media Group.)

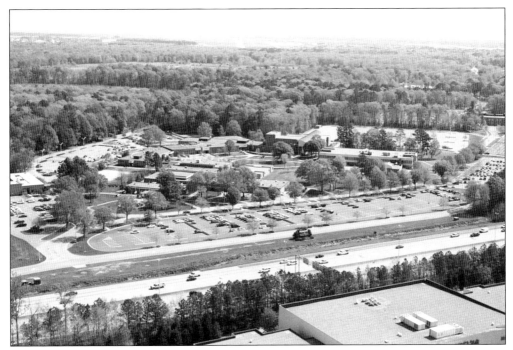

This 2012 photograph not only demonstrates the growth of the Hampton campus but the growth of the surrounding area. What began as thick woods, swamps, and a creek is now a vibrant neighborhood bordering the campus to the north and west and an office park to the south and east. (Photograph by Larry Byer, courtesy of the Daily Press Media Group.)

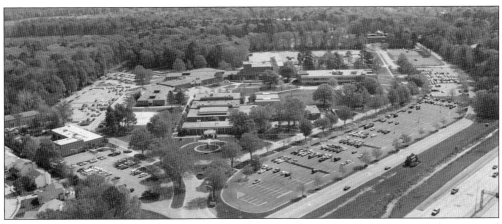

This aerial photograph of the Hampton campus was taken in 2012. From the original three buildings—Harrison, Diggs, and Moore Halls, constructed in 1967—the campus has expanded to include Wythe and Griffin Halls, constructed in 1973–1974; Hastings Hall, constructed in 1984; the Automotive Lab, completed in 1986; the Plant Services Building, completed in 1989; the Peninsula Workforce Development Center, constructed in 2000–2001; Templin Hall, opened in 2002; and the Hampton III Building, purchased from the City of Hampton in 2006. (Photograph by Larry Byer.)

Thomas Nelson's Science, Engineering and Technology (SET) Division, through its associate of science degree, continues the college's long tradition of providing scientific education to peninsula students. Graduates of this program gain the knowledge and skills necessary to transfer to four-year institutions to continue their education through both traditional lectures and laboratories, where they learn to think scientifically and use the instruments of scientific research.

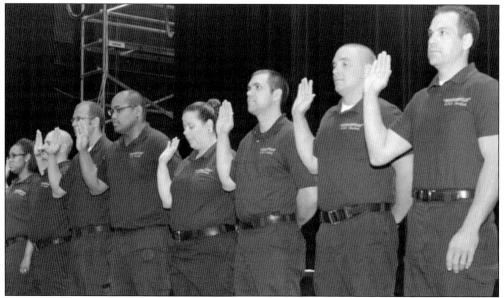

The college created a new health professions division, based at the Historic Triangle campus, in 2012 to bolster its ongoing efforts to enhance the college's Science, Technology, Engineering, Math and Health (STEM-H) programs. The new division encompassed all dental hygiene, nursing, emergency medical services, and phlebotomy programs. Shown here are the first graduates of the EMS program.

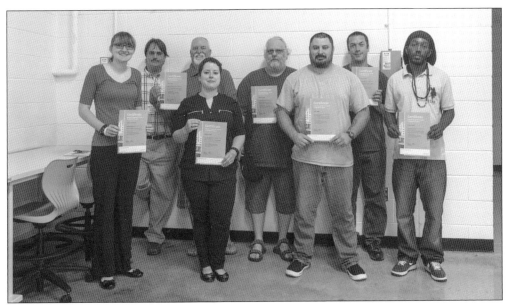

Thomas Nelson has many partners in the Virginia Peninsula's business and industrial community. The Siemens Mechatronic Systems Certification program is an internationally recognized comprehensive skills certification in mechatronic systems. Pictured is one of the program's first groups of graduates.

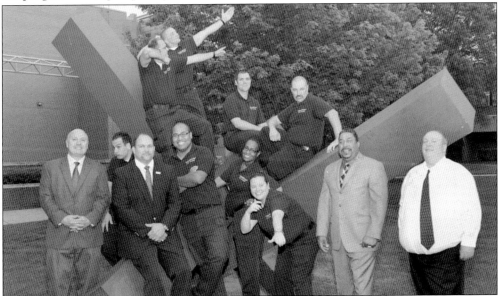

As part of its health professions programs, the college offers an EMS career studies certificate that prepares students to become entry-level emergency medical technicians. A paramedic program began in the spring of 2015 with a four-semester cohort model at the Historic Triangle campus in Williamsburg. The program prepares students who have current Virginia or national registry certification as an EMT to complete the paramedic certification. Upon completion of the four semesters of courses and clinical work, students will be prepared to test to become certified national registry paramedics. Pictured here are instructors and students from the 2016 class.

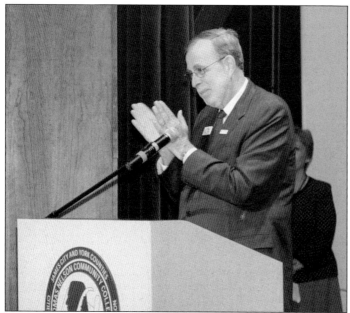

President Dever congratulates the graduates of the new EMS program. Even though the program is based at the Historic Triangle campus, the graduation ceremony took place in Hampton's Mary T. Christian Auditorium. Standing behind Dever is Dr. Lonnie Schaffer, vice president for academic affairs. It was through the efforts of her office that the college was able to launch the accredited EMS program.

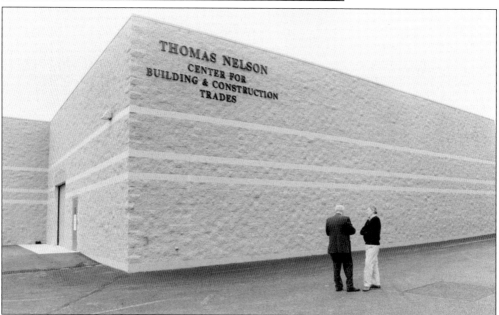

In partnership with Goodwill of Central and Coastal Virginia, TNCC opened the Center for Building & Construction Trades in 2015. Located at the Goodwill Industries facility in Hampton, the center offers short-term training to meet the expanding need for skilled workers in construction and building trades. Training at the center takes place in a space replicating real worksites of apartment and building maintenance, HVAC, electrical systems, and weatherization technicians. The partnership also allows students to benefit from the expertise of both partners, including services in career counseling, job searching, GED applied instruction, adult career coaching, workplace soft skills, on-the-job training grants, and services for mental health, family counseling, alcohol, and drug rehabilitation. Charles Nurnberger (left) and John Calver are pictured here.

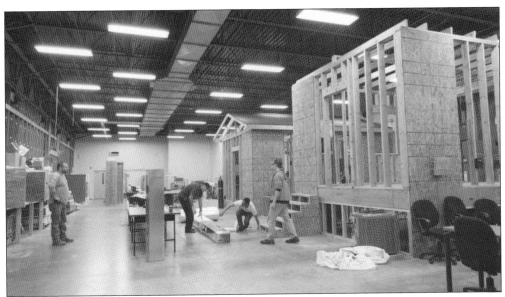

At the partnership signing for the Center for Building & Construction Trades in 2015, President Dever said, "We're in the business of changing lives. You do that through the long history that Goodwill has to prepare people with the skills and abilities that they need to be self-sufficient through work. We do it through the instruction that we offer in our academic and workforce programs at Thomas Nelson."

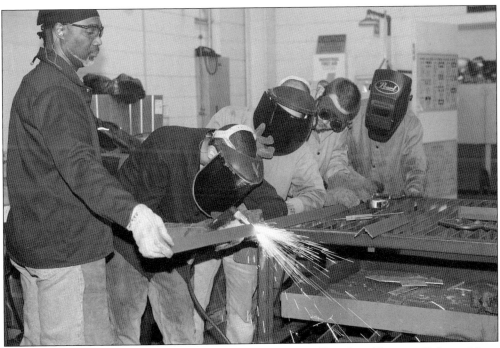

Welding is one of the oldest occupational programs offered at Thomas Nelson. Many of those who graduate from the program earn well-paying jobs with local companies. Three quarters of Thomas Nelson's students, after leaving the college, remain in the area, working and living in the communities served by the college.

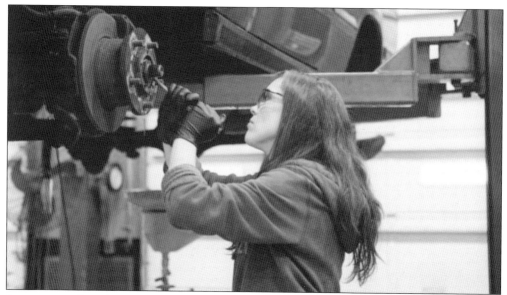

As a comprehensive community college, TNCC has always prided itself on offering associate degrees and certificates in many fields that bring career opportunities to peninsula residents. Success is indeed closer than one might think, with available associate of applied science degrees in automotive technology and advanced integrated manufacturing technology, and industry certifications in fields such as welding. Automotive technology was the first program approved for the college by the state board.

Graduates of Thomas Nelson's HVAC program have no problem finding employment. The certificate program offers courses in heating systems, planning and estimating, mechanical codes, and more, and makes the graduate eligible for journeyman licensing.

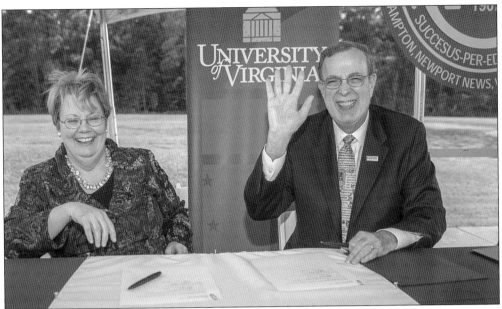

Pictured during a light-hearted moment at the 2014 signing of the agreement between Thomas Nelson and the University of Virginia (UVA) to inaugurate the bachelor of interdisciplinary studies (BIS) program at the Williamsburg campus are UVA president Teresa Sullivan (left) and TNCC president John Dever. The BIS program allows TNCC students to complete a UVA undergraduate degree while attending the Historic Triangle campus in Williamsburg. Upon completion of their degree, students travel to the UVA campus in Charlottesville for graduation.

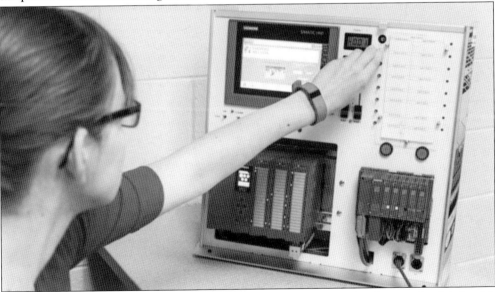

Advanced integrated manufacturing technology is a much-sought-after credential. In this photograph, a student is working with a Siemens human-machine interface device. In 2014, Gov. Terry McAuliffe challenged Virginia higher education to increase the number of awarded credentials threefold. The Virginia Community College System is leading the way with programs like those offered at Thomas Nelson.

The annual All College Day ceremony held every August is a convocation program designed to welcome faculty back to the college and to welcome new faculty and staff who have joined the college over the past year. The centerpiece of the program is the president's annual address to the college. In this photograph taken at All College Day in 2016, President Dever is addressing the college.

Each All College Day is followed by a lunch for the entire college held in the Library Gallery in Wythe Hall. Here, three staff members enjoy dessert and some time to sit and chat. From left to right are Marshall Shuff, Bill Alvis, and Jesse Machen.

Enjoying All College Day are Tracy Ashley (left) and Alicia Riley. Ashley is the director of development, and Riley is the events planner for Thomas Nelson. Both work with the vice president for institutional advancement, Cynthia Callaway (not pictured).

Thomas Nelson Community College introduced a program in dental hygiene at the Historic Triangle campus in Williamsburg. The program is housed in a state-of-the-art dental hygiene clinic that, along with its mission of graduating highly trained hygienists, is open to the public. People from the Williamsburg area attend the clinic for reduced-cost cleanings.

Erica Snow is one of seven students who completed the Dental Hygiene program in May 2012, its first graduating class. Thomas Nelson's hands-on curriculum, state-of-the-art equipment, and small class sizes that allow for one-on-one instruction gave Snow a chance to reach her ultimate career goals. She credits the instructors for exposing her to the latest research, products, and technology.

The Thomas Nelson Office of Athletics and Intramurals coordinates competitive games for the Thomas Nelson Gators with other junior colleges as well as on-campus intramurals in baseball and basketball for both men and women. A new peer-mentoring program called MERIT even aims to help young men stay enrolled and graduate via their participation in sports.

The associate of science in science at Thomas Nelson Community College is designed for individuals interested in gaining knowledge and skills to be successful in an entry-level technical science field or to transfer to a four-year institution to complete a bachelor's degree in a science-related field. Here, associate professor of chemistry Riham Mahfouz instructs a student.

Each year, the college presents the Presidential Leadership Award to an outstanding member of the community. Since Thomas Nelson serves various localities, the awardee may be selected from almost anywhere on the Virginia Peninsula. This photograph shows Dr. Turner Spencer being given the Presidential Leadership Award in 2014. The ceremony took place in the Mary T. Christian Auditorium. Dr. Spencer was one of the college's founding faculty members and is a member of the Thomas Nelson Educational Foundation board.

The sciences are an important component of the health sciences curriculum. Anatomy and physiology are required for all nursing and pre-nursing students. In this photograph, two students are working together to complete a lab project.

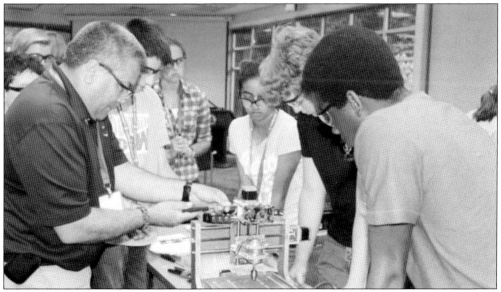

Whether high school students are interested in computer assisted design (CAD) or flying drones, through the Hover Games and Technology Summer Camp, Thomas Nelson faculty members bring their expertise into the peninsula community for the benefit of area youth. Even middle school students can join the fun with hands-on, interactive Summer Science Camps led by science faculty.

Thomas Nelson Community College officially kicked off its 50th anniversary celebration with an activity in the Wythe Hall Gallery on the Hampton campus. Hampton mayor Donnie R. Tuck presented a resolution to the college declaring August 29, 2017, to be Thomas Nelson Community College Day in the city of Hampton. Pictured here are two musicians from Yorktown who performed Colonial period music on fife and field drum.

As part of the festivities for the 50th anniversary kickoff, a cake-baking competition known as Cake Wars was held. The winning cake was from the Science, Engineering and Technology Division. From left to right are Nicole Houser; Nicole Jones; Science, Engineering and Technology Division dean Seyad Akhavi; and Beth Dickens.

The 50th anniversary festivities also featured cheers and dances by the TNCC cheerleaders. Pictured are two members of the cheerleading squad. The cheerleaders offered a student presence at the mostly faculty event, thus prompting several students to stop and take part in the cake-tasting contest.

Pictured here are the finalists and winner of the cake-baking contest held as part of the 50th anniversary celebration. From left to right are Seyed Akhavi, dean of the Science, Engineering and Technology Division; Thomas Nelson Jr. from Yorktown; Charles Swaim, dean of the Business, Public Services, Information Systems and Mathematics Division; and Patrick Tompkins, dean of the Communications, Humanities and Social Sciences Division. Dean Akhavi's team won the competition.

In commemorating the college's 50th anniversary, the organizing committee wanted to demonstrate the college's connections to the Colonial roots of its namesake. Reenactors were hired from Yorktown. In this photograph, President Dever (center) is talking with actors portraying the "Town Crier" (left) and Gov. Thomas Nelson Jr.

As part of the 50th anniversary ceremony, an actor portraying Thomas Nelson Jr. (right) read aloud a letter written for the occasion. In this photograph, he is presenting the letter to President Dever.

Each year, the college recognizes Veterans Day by honoring those staff members who served in the military. In this photograph, members of the President's Cabinet are serving those who have served. From left to right are Dr. Daniel Lufkin, vice president for student affairs, serving Mike Goodeyon, maintenance supervisor.

Commencement is the highlight of the academic year. It is a time of festivities for faculty, staff, and especially students. Shown here from left to right are Dr. Gregory McLeod, provost for the Historic Triangle campus; Geraldine Mathey, and Sharolyn Graybiel.

Pictured at the sign-in table for commencement are, from left to right, Geraldine Mathey, Charles Nurnberger, and Lonnie Schaffer. Faculty and administrators are required to wear the cap and gown representing their most recent degree. This type of clothing is referred to as regalia. Both Nurnberger and Schaffer are carrying their regalia in garment bags.

Pictured here is part of the graduating class of 2015. TNCC traditionally holds its commencement ceremonies in the Hampton Coliseum. In the early days of the college's history, the events were held outdoors on campus. The graduating class has grown too large for the campus to accommodate the number of students and family members who attend.

The Dental Hygiene program annually graduates between 10 and 20 students. The program is so successful that it has a waiting list of students wanting to enroll. From 2012 through 2014, all graduates of the program found employment almost immediately after graduation.

The guest speaker for the 2014 commencement was Governor McAuliffe, a strong supporter of education and, in particular, the Virginia Community College System.

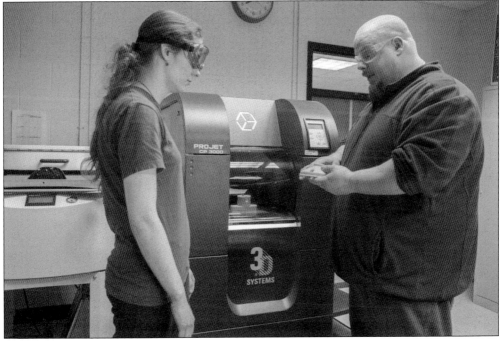

Exciting days are ahead for Thomas Nelson as the college creates the workforce for the 21st century. The use of state-of-the-art facilities and a dynamic curriculum puts TNCC and its students at the forefront of innovation. Instructor Thomas Pringle is pictured working with a student.

In 2016, Thomas Nelson's baseball program joined the National Junior College Athletic Association. The NJCAA's mission is to promote and foster two-year college athletics in an equitable and affordable atmosphere. Thomas Nelson's baseball team is pictured here. Standing at far right is coach and athletic director Chad Smith. The team's first day as a member of the NJCAA featured a double-header—the Gators lost the first game but rallied to win the second.

The car show has been an annual fundraising event since 2009. The funds raised from entry fees and donations go toward a scholarship fund for students in the Automotive Technology program. In this photograph, President Dever (right) presents the 2014 President's Award to Lewis Elam.

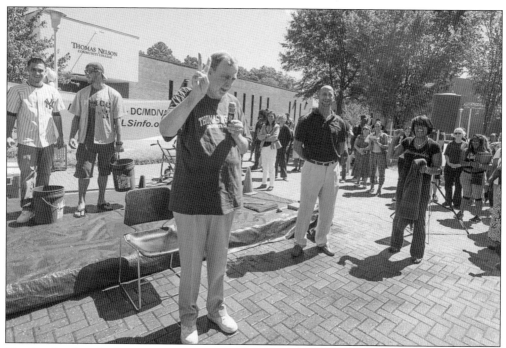

The "ice bucket challenge" was a national phenomenon that started in 2014 to raise funds for the treatment of ALS (amyotrophic lateral sclerosis), commonly known as Lou Gehrig's Disease. In this 2015 photograph, President Dever indicates that as president of the college, he will be doused with not one but two buckets of ice-cold water.

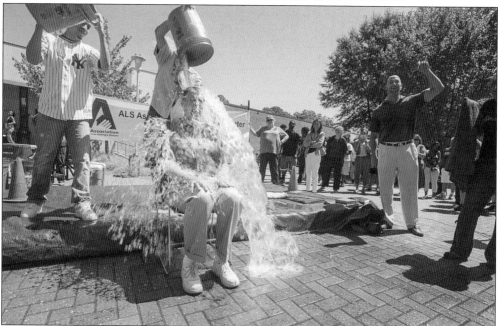

Here, President Dever receives his first of two buckets of ice-cold water as part of the ice bucket challenge. In good fun, and for an excellent cause, the president's entire cabinet—nine people—took part in the event, with each receiving a thorough drenching.

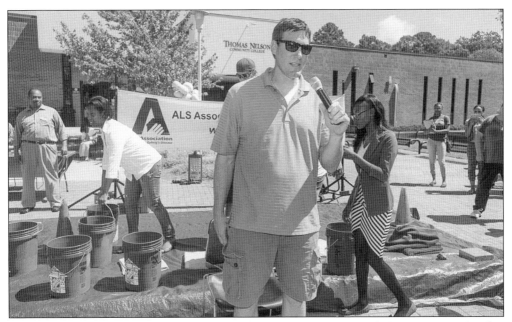

Dr. Daniel Lufkin, vice president for student affairs, organized the TNCC ice bucket challenge in 2015. Here, he is speaking to the audience before being doused with a five-gallon bucket filled with a mixture of ice and water.

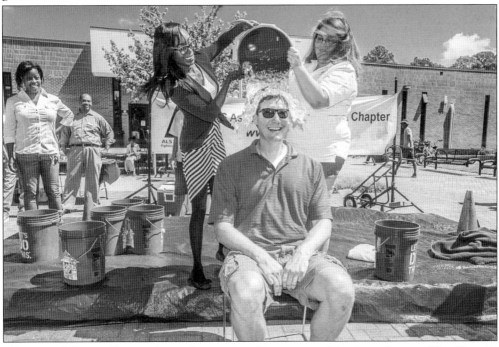

All in good fun, Lufkin smiles as he receives his requested bucket of water. The Historic Triangle campus in Williamsburg also took part in the festivities, as Interim Provost Richard A. Hodges and vice president for institutional advancement Cynthia Callaway were doused with buckets of water in a ceremony simultaneously conducted with the Hampton event.

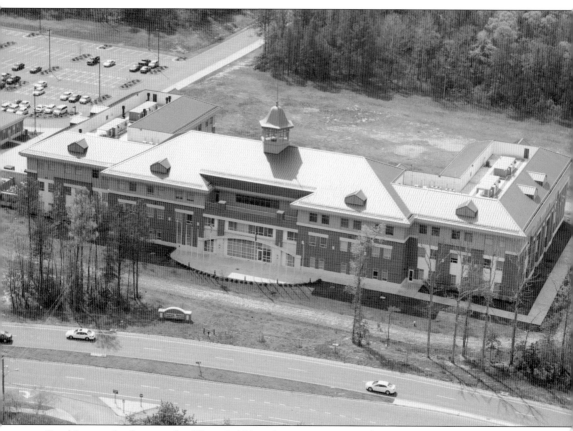

Looking to the future, the Historic Triangle campus opened in 2009 as the newest campus in the Virginia Community College System. The master plan for the campus includes the addition of three more academic buildings, a parking garage, and a Workforce Development Center. Currently, the Workforce Development Center is located in a leased facility in the Newtown area of Williamsburg.

The Thomas Nelson Community college mascot has come a long way since its first inception as the Swamp Stomper. Pictured at the 2016 commencement ceremony at the Hampton Coliseum is Gilbert the Gator congratulating all the newly minted graduates.

Discover Thousands of Local History Books Featuring Millions of Vintage Images

Arcadia Publishing, the leading local history publisher in the United States, is committed to making history accessible and meaningful through publishing books that celebrate and preserve the heritage of America's people and places.

Find more books like this at
www.arcadiapublishing.com

Search for your hometown history, your old stomping grounds, and even your favorite sports team.